Dear Scotland was first performed by the National Theatre of Scotland on Thursday 24 April at the Scottish National Portrait Gallery.

PERFORMERS

Maureen Beattie
Ryan Fletcher
Lesley Hart
Tunji Kasim
Anne Lacey
Colin McCredie
Sally Reid
Anneika Rose
Benny Young

(Audio performances by: Michael Clark and the Oncologists: Professor RJ Steele and Professor Sir Alfred Cuschieri)

CREATIVE TEAM

Peter Arnott, Writer
Jo Clifford, Writer
Rob Drummond, Writer
Janice Galloway, Writer
David Greig, Writer
Zinnie Harris, Writer
Iain Heggie, Writer
Stuart Hepburn, Writer
Jackie Kay, Writer
AL Kennedy, Writer
Hardeep Singh Kohli, Writer
Liz Lochhead, Writer
Iain Finlay Macleod, Writer
Nicola McCartney, Writer
Johnny McKnight, Writer
Linda McLean, Writer
Rona Munro, Writer
James Robertson, Writer
Ali Smith, Writer
Louise Welsh, Writer

Joe Douglas, Director
Catrin Evans, Director

Janice Burgos, Costume Designer and Supervisor
Laura Donnelly, Casting
Jo Masson, Production Manager
Catherine Dick, Front of House Manager
Hazel Price, Company Stage Manager
Neil Watson, Sound Technician

**NATIONAL THEATRE OF SCOTLAND**

It is our ambition to make incredible theatre experiences for you, which will stay in your heart and mind long after you have gone home.

We tirelessly seek the stories which need to be told and retold, the voices which need to be heard and the sparks that need to be ignited. We do this with an ever-evolving community of play-makers, maverick thinkers and theatre crusaders. We try to be technically adventurous and fearlessly collaborative. We are what our artists, performers and participants make us. And with no stage of our own, we have the freedom to go where our audiences and stories take us. There is no limit to what we believe theatre can be, no limit to the stories we are able to tell, no limit to the possibilities of our imaginations.

All of Scotland is our stage, and from here we perform to the world. We are a theatre of the imagination: a Theatre Without Walls.

For the latest information on all our activities, visit our online home at nationaltheatrescotland.com

Follow us on Twitter @NTSonline and join in the conversation #dearscotland

Find us on Facebook: NationalTheatreScotland

**The Scottish Government**
Riaghaltas na h-Alba

The National Theatre of Scotland, a company limited by guarantee and registered in Scotland (SC234270), is a registered Scottish charity SCO33377). The National Theatre of Scotland is core funded by the Scottish Government.

# Dear Scotland

## Notes to our nation

National Theatre of Scotland

**Luath** Press Limited

EDINBURGH

www.luath.co.uk

First Published 2014

ISBN: 978-1-910021-49-1

The paper used in this book is recyclable. It is made from low chlorine pulps produced in a low energy, low emissions manner from renewable forests.

Printed and bound by
DS Smith, Glasgow

Typeset in 10 point Quadraat by
3btype.com

Dear Scotland was supported by Creative Scotland and Homecoming 2014

## ARTWORKS

Michael Clarke © David Williams

Michael McGahey © Maggi Hambling

Poets' Pub © Alexander Moffat

Robert Bontine Cunninghame Graham © the estate of Sir Jacob Epstein

Muriel Spark © Alexander Moffat

Queen Elizabeth II © Carl Court

Jackie Kay © Michael Snowden

Three Oncologists © Ken Currie

Chic Murray, Artwork by Derek Gray, part of the Fizzers® caricature collection

Jimmy Reid © Kenny Hunter

## TEXTS

Copyright © 2014 – AL Kennedy, Front Step Ltd, Ali Smith, Zinnie Harris, Peter Arnott, Iain Finlay Macleod, Louise Welsh, Jackie Kay, Jo Clifford, James Robertson, Janice Galloway, Johnny McKnight, Linda McLean, Liz Lochhead, Iain Heggie, Nicola McCartney, Rona Munro, Rob Drummond, Stuart Hepburn, Hardeep Singh Kohli.

## PERFORMANCE AND OTHER WORKS

All rights whatsoever in these Works are strictly reserved and application for performance or reproduction etc. should be made before rehearsals in the following manner:

AL Kennedy – Antony Harwood Limited, 103 Walton Street, Oxford OX2 6EB

David Greig, Zinnie Harris, Linda McLean, Rob Drummond – Casarotto Ramsay & Associates Ltd., 7–12 Noel Street, London W1F 8GQ

Ali Smith, Jackie Kay – Wylie Agency 17 Bedford Square, London WC1B 3JA

Peter Arnott – Playwright Studio Scotland, 350 Sauchiehall Street, Glasgow G2 3JD

Iain Finlay Macleod, Jo Clifford – Alan Brodie Representation, Paddock Suite, The Courtyard, 55 Charterhouse Street, London EC1M 6HA

Louise Welsh – Rogers, Coleridge & White Ltd. 20 Powis Mews, London W11 1JN Agency

James Robertson – AP Watt at United Agents, 12–26 Lexington Street, London W1F 0LE

Nicola McCartney – United Agents, 12–26 Lexington Street, London W1F OLE

Janice Galloway – Blake Friedmann, first floor, Selous House, 5–12 Mandela Street, London NW1 0DU

Johnny McKnight, Hardeep Singh Kohli – Troika, 10a Christina Street, London EC2A 4PA

Liz Lochhead – Knight Hall Agency, Lower Ground Floor, 7 Mallow Street, London EC1Y 8RQ

Iain Heggie – Julia Tyrrell Management, 57 Greenham Road, London N10 1LN

Rona Munro – Independent Talent Group, 40 Whitfield Street, London W1T 2RH

Stuart Hepburn – Sayle Screen Ltd. 11 Jubilee Place, London SW3 3TD

No performance may be given unless a licence has been obtained.

No rights in incidental music or songs contained in the Work are hereby granted and performance rights for any performance/presentation whatsoever must be obtained from the respective copyright owners.

# Contents

# Introduction

Many people sympathised that putting together my first season of work for the National Theatre of Scotland in a year as significant as 2014 would be a daunting prospect. 'No pressure' was whispered under the breath on more than one occasion, with a mixture of support and challenge. In fact the eagerness of artists to engage with an urgent cultural debate meant there was only one thing that was daunting: what to leave out. Theatre in Scotland can still claim to have a popular role, both in what it talks about and who it talks to, a role that has been greatly damaged in England as ticket prices have rocketed and public subsidy is repeatedly cut. Theatre is arguably the art form that best explores the character of individuals in their wider social, economic and political background. With this in mind, the National Theatre of Scotland has set out to provide a platform for both artists and audiences to reflect on Scotland's past and future.

In a year dominated by a day in September, but also packed with events and anniversaries including the Commonwealth Games, the 700th anniversary of Bannockburn and 100 years since the start of the Great War, our programme has been imagined as a conversation between now and then, including a cycle of new history plays about three little-known medieval kings, James I, II and III of Scotland, a celebration of the idiosyncratic work of humourist Ivor Cutler, but perhaps most thrillingly the *Great Yes, No, Don't Know, Five Minute Theatre Show* where anyone around the world can pitch to have their five minute piece of theatre live streamed as a 24 hour international event. In preparation for that open access event, I wanted to invite some of the country's most celebrated writers to create their own five-minute theatre pieces.

The brief was simple but specific: write a five-minute monologue for one of the people featured in the Scottish National Portrait Gallery. It had to begin 'Dear

Scotland', and be imagined as a message to the present moment. Of course, writers being what they are, they have in many cases completely ignored the rules! The writers would choose their own portrait and approach the brief in whatever way they chose. Two routes would be mapped out round the Gallery, and audiences would encounter actors who would be the mouthpieces for the thoughts and words of both subject and writer. The monologues would also be filmed and available online once the performances were over, providing a provocation for anyone to send us their own Dear Scotland postcards.

Perhaps it's a postcard, perhaps it's a love letter, perhaps it's a eulogy. You'll find all those here. Some writers have engaged in an act of ventriloquism, imitating the speech patterns and rhythms of their subject, some have engaged in an act of historical vandalism. Some have put unambiguous political views into the mouths of iconic figures, whilst many have foregrounded nameless figures that have in the past been relegated to the background. Many of the characters reflect on the work of art that has captured them forever in one of Scotland's most evocative collections.

Together I hope they provide a unique snapshot of both Scotland's past and imagined futures, often surprising, nearly always irreverent, and always expressed with intelligence and passion.

*Laurie Sansom*, Artistic Director, National Theatre of Scotland
April 2014

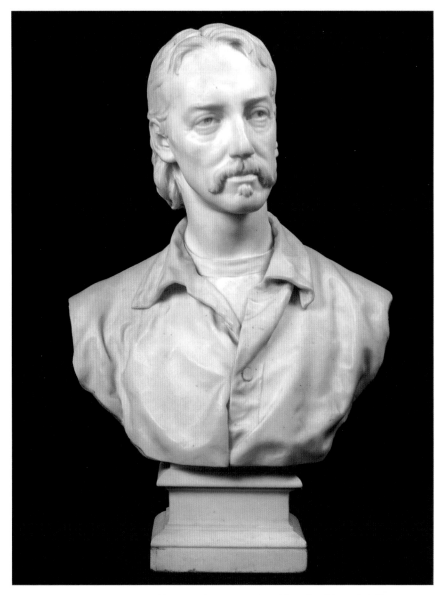

ROBERT LOUIS STEVENSON · David Watson Stevenson · Scottish National Portrait Gallery

# AL Kennedy

Dear Scotland,

I am sure there is a deal I have forgotten, but you are with me still. Although I am in many senses an abbreviated man: reduced to this poor marble and with no means of locomotion, no hands or even arms and with, if not the better portion of a man's body, then certainly a significant portion left very signally unrepresented, yet still the seats of heart and mind remain. This elicits a type of hope. There is often hope. And if I can no longer hold a pen, I can speak after a fashion to this time beyond my own within which – as I understand it – communications are either constrained to something approaching the petty din of teaspoons upon saucers, or else the cries of those dismayed, lost and degraded, the unattended men and women, the deserted and unguided children of no matter what age. We can still, every one of us, be children when necessity or fancy takes us. In other words, your century – this almost untouched century – this already much-abused century – is not unlike my own.

And from my place within the Great Hall, I know you and hear you as you pass, wandering to and fro as I no longer can, or else never could: the status of a statue being an equivocal one. I am, I must confess, neither quite the man, nor quite the stone I was. Whatever I am, I have all the time the world of art provides and all of the generous leisure afforded to the dead, in which to learn your troubles and delights. And in the night when I am left alone with other forms bereft of motion, other echoes of faces both notorious and loved, I still attend. Beyond these walls, I feel your lives as they incrementally create their possibilities, spring up like orchards with wholesome and beguiling and

unholy fruit. And meanwhile destroying or avoiding the wide expanding webs of other opportunities. I feel your futures stretching out like reckless sleepers.

And would it be wise for a shadow, a mere object to offer you advice? Perhaps not. And yet, if I keep silent, who else will insist that you hear them? Only the usual voices of special interests, the calls of self-appointed power both temporal and divine. And naturally the press. As an author of fictions, I feel I am properly qualified to comment upon the work of pastors, politicians and pressmen and to question the unending influence of those who blithely publish falsehoods and call them truths. As a man who once presented men with honest lies, I am grieved to find my trade so ill applied and poorly practised. As a stone, I am astonished by mankind and find you to be the worst angels, the most noble monsters. In this, again, your age is not unlike my own.

So what might I tell you that could serve you well, dear Scotland? Perhaps that you would not be wise to ever make a bargain that buys a portion of the devil and a promise to your meanest needs. Rise beyond the glamour of mere commerce and the morals of Sawney Bean. With compromise and forgetting of your best selves, your fortunes may prosper passingly, but who will take your darker burdens from you as you near your end? What will you leave your children beyond the legacies of wastefulness? Indulge wrongs less and see them more.

And what of your joys, Scotland? What of your pleasures beyond the influence of preaching and harsh masters? Let your time fill with passions and adventures. Know loves, ones that would cross a continent to be fulfilled and think it nothing. Be nourished on moonshine and distilled reality and the mercy of true hearts – become a place of the wildest and yet the most prudent extremes. And when you view the world do so clearly, not through the narrow tunnel of a dirty spyglass, not through a straw. If you do not long to find yourself transported into other countries, be travellers in heart and mind at least. Be large citizens of unanticipated worlds who might together form a land of wonders,

perhaps douce wonders, wee wonders, sleekit wonders, but all the same. Be not penny wise and virtue foolish and, dear Scotland, as each short and tender span of your good people burns away, help them find the will to speak the truth, resist oppression and live and live and live as bright as any hope, or daydream and as deep as any star.

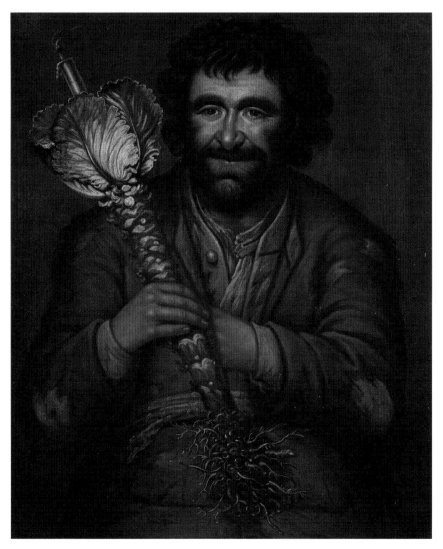

THE CROMARTIE FOOL · Richard Waitt · Scottish National Portrait Gallery

# David Greig

Dear Scotland,

My name is Jamie Henderson and I'm a fool. Am I the biggest fool in Scotland? That's not for me to say. The biggest fool in the Highlands? It's possible. But, whatever else, I think most people would agree I'm the biggest fool in the greater Dingwall area at time of writing.

Which is 1731.

I am recently back from Edinburgh whence to get my portrait painted by Mr Richard Waitt. Now, I don't know if you've ever had your portrait painted by Mr Richard Waitt but, let me tell you, it's no picnic. The process involves a tremendous amount of standing still. Of course, my professional instinct, in any moment of stillness is to fart. Not, a natural fart, a fool's fart. Something like, for example, screwing my face up, slightly crumpling my body, and releasing a tiny high pitched noise out of the side of my mouth. Like this. Followed immediately by an expression of mild bewilderment.

Well, I think that's funny but you don't want to be trying that sort of thing with Mr Richard Waitt. At least not while he's trying to paint you. For a city man he has a very rural vocabulary. In any event, the whole business meant for some days I was compelled to be still and so I found my mind wandering.

Now, in Edinburgh, as I'm sure you know, they're currently having an 'Enlightenment'. It's quite a big one. The biggest there's been. The streets are full of men having ideas. One can barely cross the Lawnmarket without bumping into a man having an idea. The taverns and closes of the High Street throng with men making

observations. Even sat at their pot stool they philosophise. They say an Edinburgh man's urge to enlightenment is so strong that if he's struck by an observation whilst making love he'll turn his partner onto her hands and knees and use her as an emergency escritoire, so powerful is the urge to record.

Well, something of the Enlightenment spirit must have infected me because, whilst in Edinburgh, I decided to set down some observations of my own. Mr Adam Smith has lain down the lineaments of Economics. Mr David Hume has described cause and effect. Now I, Jamie Henderson of Cromartie, hereby set down – 17 Rules For Playing The Fool.

The following things are funny.

1. Pretend you know what you're doing when you don't.
2. Pretend you don't know what you're doing when you do.
3. Use low language when speaking of important things.
4. Use high language when speaking of trivialities.
5. Make threats whilst appearing ostentatiously clumsy.
6. Shrink from weaker creatures: ducks, children, women etc.
7. Use the word 'Pie'.
8. After a fake fart, effect a post-plosive trouser opening and pretend to waft.
9. Imply old women are sexual.
10. Imply young women are naïve.
11. Imply old men are cuckolds.
12. Imply young men are consumed with lust.
13. Name local foodstuffs...
16. Make out you don't know how to count.

All of the above are important but there is one rule to set above all, the most important rule for fooling, and that is this:

17. The fool's job is to distinguish between the foolish and the wise. To do this you must first take that which is most important to you and you must mock it. For example, if your deepest care is your dignity – then take a kale, pull it from the ground, plant in its head a candle and make of it a silly torch... then take your torch and wave it in the faces of the lords and ladies and say, with all sincerity, 'Ladies and Gentlemen, this torch is my dignity, this torch is my liberty and one day, one day far far in the future... this torch will be the symbol of my enlightenment.'

Everyone in the room will laugh.

And in that moment the foolish will be distinguished from the wise.

Those are my rules. I commend them to posterity.

Yours faithfully,

Jamie Henderson

MICHAEL CLARK · David Williams · Scottish National Portrait Gallery

# Ali Smith

Dear Scotland,

look into my face.

No. I don't mean him.

No point in looking a dancer in the face.

Look down. Look below. No, not there.

I mean me.

The knee.

The Scottish knee of this Scottish dancer. This portrait celebrates me. And it's about time too. It's timely.

You want the Scots measure of me? Imagine a fist with me as a knuckle. I'm the place where knuckle meets muckle. You can't keep a good knee down, no, it'll nudge at you, nose at you blunt and insistent as a foal, then stronger, a bit stronger, a little bit harder, into upward shove, into full flown body thrown leap, the kick in the air, the kick in the gut of the prayer – imagine, centuries of presbyteriana, thick as gone-off broth, repression layered rock formation thick, and we came through it airy, flying, through it like a knee through denim. Anything that blocks me won't for long.

I'm the largest of the joints. I am complex, articulated. I'm pivotal. I'm hinge, I'm flexibility. I'm all about extension. I'm fibrous, walled, pocketed, elastic, plateaued, and like the heart, my ligaments are coronary. And like the heart I can crack and rip. Dislocate me, stress me, block me, lock me, think I'm going to give way? You've got me, deep in the skin of you. I am mobility.

So never mind the wine on that table. Never mind him. For I can set a dancer free.

Born north of Aberdeen and grew up on a farm. The real reel o' Tullich, the dancer son of the farmer. They tell the story now, about how you asked at the age of four to go to your sister's dancing school. You don't remember, but I do. You're only wee, five years old, pas de basque, pas de basque. The words like a magic spell, but dancing isn't magic, no, it's more a kind of work. Dance is social. Dance is people. Pas de basque. Pas de basque again.

Five times a week off on the bus for more lessons into the toon. Aberdeen was very glamorous. At the school you went to at home there weren't any other dancer boys. And if they'd known that's what you were, they'd've kicked your head in and stamped on me. You learned to keep in with the tough boys, to survive. And then one day a man who was singing on *Top of the Pops* on TV put his arm round another man, and you thought,

oh my goodness, there are other people like me.

Somewhere.

Maybe.

On we go, thirteen years old, off down south with Billy your brother to take you to the Royal Ballet. They flung you higher than a Highland fling, they threw you across rooms. You learned to ricochet.

Between the farm and the toon. Between the north and the south.

Then you left school. It was time.

Listen. An out of tune fiddle. A white path through fields. A beautiful young sailor dancing along it, slow-stepping. The sailor dances the hornpipe. Then it's over. It's a cameo, less than three minutes long in the film called *Comrades*, made by Bill Douglas. But the going of the sailor, it's a loss, a thump to the heart.

What next? Where'd you go? International. Take the girdle off the world, it'll only take a minute, got a knife? That dancer, oh he can do anything, strip the dashing white dashing black sergeant with the best of the skinners and glovers, you make me wanna shout we could be heroes not excluding anyone – the Fall, the rise again over and over, so thank god we did all those exercises.

Then there's addiction. That made the papers. What it feels like, to be here. Doing it to see. I've never felt that before. The numbness, the speed, the only anes sober the calf and the coo, and through it all, in the middle of the leg, still flexible, waiting, getting us through it naturally, me, the knee –

But you know what dance is? It's about time. It tells time, dispels time. Dance is the mantra. It's what surfaces are for. It's the mystery tour back to the source. Timely. There's your mum in her nineties now, you next to her in bed reading *Grey Granite* out loud, the rhythm of the language through both your heads like a river. Or you read out loud to her the book your brother wrote about semantics, all a body, language, all a part of the dance. It's all the rages, all the stages, it goes through all of us, him, her, them, you, me, the choreography, layered through us all like invisible geography.

Sometimes it's renaissance. Sometimes tragedy. But even when all the houses go, like the poet says, under the sea? and all the dancers, under the hill? Then listen. There'll be a fine bit dance going on inside that hill.

Come on, I'll carry you. I'll take your weight. I'll lift you. Think you're falling? I'll catch you.

And if I fall myself, I'll be every broken thing for you, and then when you think I'm finished the dancing, look again, I'm here –

Here's a picture of a man, a dancer made in Scotland, a bit torn open, on purpose so we can see. Human, versatile, vulnerable. Portrait of the dancer as his own left knee.

So dear Scotland, I'll end with the silent prayer of a

Scottish dancer's knee:

May you be puckish, rebellious,

always lovely,

naked to your talents,

wise to your multiplicity,

and may we dance all the old new dances

wide openly.

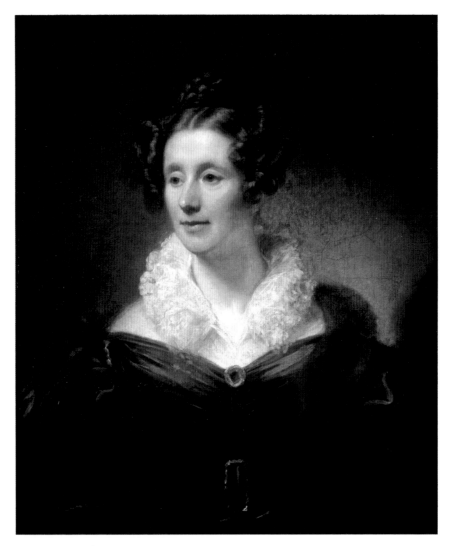

MARY FAIRFAX, MRS WILLIAM SOMERVILLE
Thomas Phillips · Scottish National Portrait Gallery

# Zinnie Harris

For the exhibition of 19th century women 'FROM OUT OF THE SHADOWS' in Gallery 9 of the Scottish National Portrait Gallery.

Written for a chorus of six women

Walk on by
Don't stand in here, there's nothing
   to see
This is the gallery of the secret place
   after all
The witches' coven
The insane
The too clever
The dangerous
Better move on, dear Scotland, this
   room isn't for you.

They haven't gone.
They're still here
Well I told them
Hurry by
Maybe they can't hear us
Maybe we should speak louder?
This room is nothing really
Tucked away in a corner
Just a few ghosts
The main galleries are along there

Out in the light
You'll miss the show
Shoo along.

Your Scotland is sorted after all
Democratic
Moral, full of equality
Look at the things you've got that we
   didn't
People like you don't get locked up
   unfairly, mistreated
You are the long faced, the wise-
   browed
The smug
People of the theatre, well-read
Well done.

No one needs our song anymore
So move along

They haven't gone
Well why haven't they gone, we've got
   nothing to say to them?

Shoo, we said.
Dear Scotland, surely you don't need to
  hear what we can tell you?
A bunch of women, long dead, do you
  need to be reminded?
We have a song, but it's a while since we
  sung it
It's an old refrain, you'll recognise it
  perhaps
Dear Scotland do you want to hear it
  again?

I can't remember how it goes.
Can anyone start?
Its been a while – oh dear
We were taught to sing, just like we were
  taught to walk with a straight back
To hell with that.

It was the song of the cowering.
I remember that
The Would Rather Not Come Out
The Hidden In The Shadows
Yes that was it
Or Behind the Stair
The Beaten
The Feart
The Put Down, or Killed With Flowers
The Underachieved, they sang it
The Gave Up Too Easily
The Never Started
There might be one or two in here
  pretending
Trying to stand tall but inside

Broken Hearted
Put Upon
The Victim
The Stand At The Back, the Try To
  Forget
The Hopeful of Next Time, does it sound
  familiar?
The Fingers Crossed it Will Change
The Stupid
The Naïve
The Punched, the Kicked
The Stopped in Their Tracks
The Forbidden, the Owned
The Trapped, the Harassed
The Told They Are Adored
The Unloved
The Ridiculed
The Frenzied
The Frustrated, the Overlooked
The Very Very Small.

No, not one of them?
Ok then, on you go. Pass through.
You are the Onlooker only. I see.
It's private
Someone else's fight
leave it to others to make a fuss
This isn't really your sort of thing
On you go then…

But if you can't
and you stayed here after all
If you can't
Then, oh cowering tiny, voiceless one

Name it.

Say the words out loud.
Say it again.
From little words spoken come great
    things.
Name it. Name all of it.
Name every single thing.
Write it down if you prefer
Only not on the sand
Write it down somewhere safe and
    send that letter
Make that call
You're a bully
You're being sexist
Racist
No he doesn't like it that way
I would rather you didn't
That language is offensive
These are her things
Children aren't possessions, neither
    are women
This isn't fair
Just because it happened this way in
    the past
No I don't agree
It makes me feel uncomfortable
I don't care if you don't like me
I would rather you didn't say that.
Just because it's on the internet
Printed on a newssheet
Sent by 'twitter'
This image is abusive

That word is offensive
We can't treat people like this
Please
Please don't.
I said stop.

That is all you have to say.
Stop.
But you have to say it again and again.
I said stop.
That is enough.
I SAID STOP

You might think you are alone
That might be the reason for not
    saying it.
Not starting
'I am just me, I can't be the only voice'
But you are never alone
'I am weak'
But you've got us
There are *hundreds* of us
See if you could be here, where we are
We may not be out there in the main
    galleries, but back here
millions
and in every word you speak out
In every banner you lift above your
    head
And in every vote, yes or no
Our song is being sung.

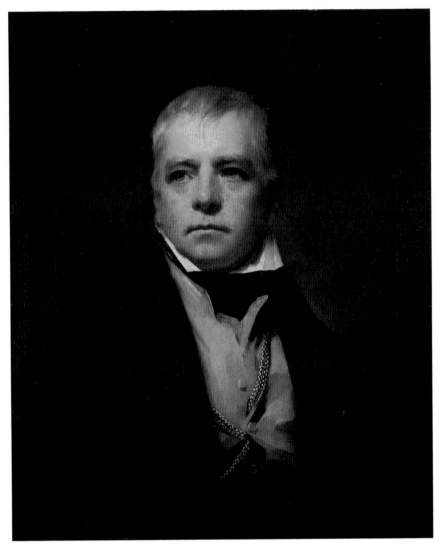

SIR WALTER SCOTT · Sir Henry Raeburn · Scottish National Portrait Gallery

# Peter Arnott

Dear Scotland,

What the hell do you think you're playing at? Have you entirely taken leave of your senses? Does the word 'Flodden'… mean nothing to you? Have you forgotten everything your grandfathers told you? I tell you this, I did not go to the considerable trouble and expense of inventing this country just so you people could piss it up a wall!

I don't understand. We made a deal, didn't we? We were allowed to stay Scottish. And we got to stick our noses in the trough. Wasn't it pretty good for us? Are you seriously saying that now there's not a British Empire anymore you just cannae be bothered. Where is your honour, Scotland?

What do you think it was like when we *were* independent? Didn't you read my books… didn't you get the subliminal message? Every ten or twenty years they came up here and knocked seven bells out of us! It's all very fine you remembering Bannockburn… but we didn't send them *hameward* very bloody often, did we? What do you think the chances of an independent Scotland would have been… *outside* the Empire? You think that was an option? You think they'd've stopped at Culloden? Look what they did to Wales! Is that what you want us to be? Pockets of chippy, incomprehensible buggers setting fire to holiday cottages in Perthshire?

We got to stay Scottish. All right? Scottish as very carefully defined. By heritage and shortbread. Not a rival bloody sovereignty on the same bloody island… The price of our remaining Scottish was that Scottish-ness be harmless… don't you get that any more? Scottish-ness is fine… as long as it doesn't piss anybody off. You know

who I'm talking about. Read the bloody papers if you can't be bothered with whole novels anymore.

You think you've got a recession now? You think you've got issues to deal with now? In 1820, at the end of the war against Napoleon, with the country bankrupt, with the Empire held together by a thread, when Castlereagh had just massacred the weavers of Manchester... a bunch of silly bastards in Condorrat decided to set Scotland free... Right? 'Scotland Free or a Desert.' They marched on His Majesty's Armoury at Carron... a bit like a bunch of students from Glasgow Caledonian or whatever it's called these days nipping up to Faslane to nick the fucking missiles... pardon me.

Of course they got wiped out... but down in Whitehall, they started to wonder... about the Scottish problem... and how they've got all of these soldiers hanging about on half pay after Waterloo... itching for someone to kick the shite out of... Somebody had to do something!

And it was me. I did it. I saved this country. That's why I'm on the banknotes and staring down at you from this picture and my statue is on all those pillars and inside that Gothic Model of Thunderbird Three out in Prince's Street Gardens. You think it's because I wrote a couple of books? Really?

All the tartan... the nostalgia... all the gift shops... where do you think all that comes from? Do you think all the poetry... the music... the uniforms... the Queen in Balmoral... the ginger wigs and the funny bunnets... the Edinburgh Tattoo... the golf... you think that all of that just happened?

In 1822, when I persuaded George the Fourth to come up here... who was it dressed everyone in tartan? Who was it who made this city into the street theatre it is today? It was me! Bagpipes were illegal... do you get that? It was me that fused the surface of Gaelic culture with guid Scots business sense and made this into a loyal, picturesque country for German George to look at...

Who was it who made Scotland safe? Me. Who made an emotional identity out of yearning for a past that was safely dead and buried? Me. All these ancient whisky

labels, the clan tartans, all of that… all of that 'tradition'… was invented inside the Union. Scottish identity dates from when I put pen to paper… INSIDE the Union.

Whisper it. Without the Union, there is no Scotland… This is not a country. This is a costume. This is a golf bag we carry for tourists. You know it's true.

We have to play the game. We are not equals on this island, okay? Our freedom… has always been in their gift. We get to be Scotland with permission. It's never been any other way.

So we can yearn, all right… we can lament… we can even strike a pose now and then… but we don't cause trouble, right? Just remind yourselves that every time we've got above ourselves, we got gubbed…

Right. I'll see you on the banknotes. And if you forget yourselves again… just look up… anywhere in Scotland… there's always a statue of me staring down at you.

Look out for yourselves,

Walter

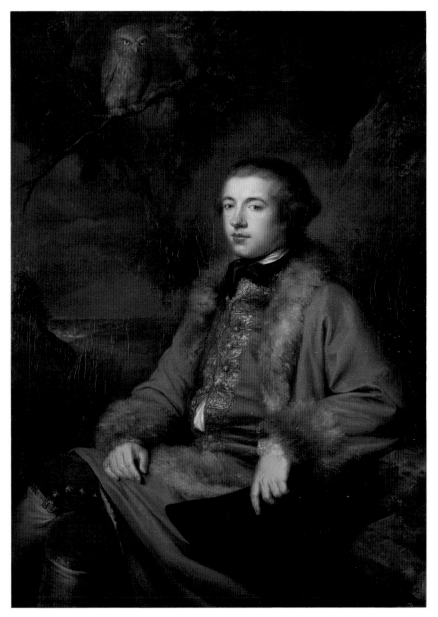

JAMES BOSWELL · George Willison · Scottish National Portrait Gallery

# Iain Finlay Macleod

Dear Scotland,

I have been accused of being a drunken, whoring, coat-tail riding, anglophile fraud, whose greatest fortune in life was to insinuate myself into the company of Dr Samuel Johnson and his set, only to show my lack of class by publishing (by God!) such conversations as should stay secret and private.

I happily admit to drunkenness and whoring, nay they were some of my happiest hours on earth. But who else but I was best placed to record for posterity the words of this great man? Indeed, would he have been so great without me? Sir, the answer is no.

Scotland, I have always found you a gloomy, backward, Presbyterian, unforgiving place. Hidebound by strange customs that do not let a man breathe. Is it any wonder I wished above all to live in London? What coffee houses in Auchinleck? What Levees with the King in Auchinleck? Would Auchinleck ever produce a man such as Johnson? Never in life. No, it only produced men such as my father.

Lord Auchinleck was intolerant of anything fanciful. He shared the general Presbyterian abhorrence of the theatre. Living in Auchinleck, surrounded by fields, I may as well have been in the Outer Hebrides. He wished me a life in the law. Is there any life as black and joyless as that of a Scottish Barrister!

Another criticism often levelled at me is that I didn't love my country. That my horror of Edinburgh manners meant I insisted on sending my daughters to private school in England – this is true – and that I also had elocution lessons to erase Scotticisms from my speech. This is also true! And what of it? You have

little idea of the times we lived in then. In how little regard even a Scottish Gentleman – Sir, I am a Baron, never forget – was held in the capital at that time.

No, Sir, even though it brought me near to ruin, it was London or nothing.

It was London and my friendship, the greatest of friendships with Dr Samuel Johnson, that changed my life. I was much agitated when I met him first and recollecting his prejudice against the Scotch I said to Davies, 'Don't tell where I come from.' – 'From Scotland,' cried Davies roguishly. 'Mr. Johnson,' said I, 'I do indeed come from Scotland, but I cannot help it.' I meant this as light pleasantry to soothe and conciliate him. He retorted, 'That, Sir, I find, is what a very great many of your countrymen cannot help.' This stroke stunned me a good deal and indeed it took me a while to recover. But recover I did, and our most unlikely friendship blossomed.

It is true I had the scheme of writing his life constantly in view during our twenty-year acquaintance. It is hard to believe now that some questioned my legitimacy in the writing of it. They suggested I was merely a fortunate idiot, who chanced upon the right coffee house at the right time. I say to them, did anyone else risk their ancestral home and lands, come so close to bankruptcy, leave the land they love, oversee the ruin of their professional life and finally ruin their health and social standing to bring another's words to print? Sir, they did not!

And what did I receive for recording forever the words of the leading light of English letters? Vilification. London society, which was once open to me was now fully closed, for fear that I should reveal private conversations. As the rogue Walter Scott remarked – my book 'though one of the most entertaining in the world, is not just what one would wish a near relation to have written.'

I was lampooned time and time again in print. My daughters were considered not well spoken enough for London high society, and considered themselves too well bred for Auchinleck. A short time after *The Life of Johnson* was published, I was forced to retreat from London and all I held dear.

I was never fully accepted in England, no matter how many steaks I ate and cock fights I attended. I could never be English, even though it was said that what I recorded of Johnson's wit and wisdom 'would become proverbial to Englishmen and long continue to direct their taste as well as their morals'.

Indeed, the only place I was fully accepted into society after publication, was *Scotland*. My dear Scotland.

And so I forever remain,

A Gentleman of Scotland.

Your most humble servant,

James Boswell, Esq.

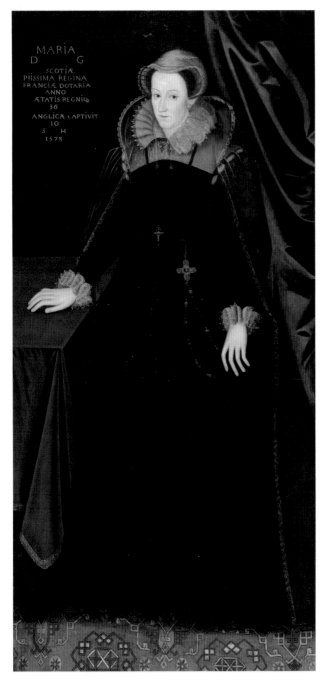

MARY QUEEN OF SCOTS
Artist Unknown
Scottish National
Portrait Gallery

# Louise Welsh

Dear Scotland,

I almost said drear Scotland because, although you are my country, I have always found you inclined to *drear*. Your weather, your religion, your men.

Your men.

They are either silent behind their beards or say out loud every boast that lumbers through their brains. Even the silent ones are boastful. They looked at me with eyes that asked what is a queen, but a woman? No better than a scullery maid for all her finery.

Scotland, I see you knit your brows and turn down your mouth. You never liked to be teased, Scotland. But I watched you tap your feet when the fiddle played and more than once I saw a tear glisten your eye when Rizzio sang.

They dealt with Rizzio, Scotland. Stuck him through fifty-six times, put so many holes in his body that no songs would ever sound from him again. They shoved a gun against the bulge in my belly, and sent me into such confusions it is a miracle I was delivered of my boy, my king.

Rizzio and my unborn bairn, remember them Scotland. They are a measure of how far men will go to control a kingdom. (They found Darnley's body in Kirk o' Field naked except for a sark. But I am no mermaid; I would not shipwreck my soul on murder.)

Scotland, you may wonder that I call you dear, but you are dear my drear, to me. We both had a rough wooing, and I am glad that one of us survived.

Dear Scotland, take some advice, direct from the grave, from one who knows the harm bad counsel can do. Judge your leaders not on what they say, but on their actions.

I believed the counsellors who told me that Darnley, that lazy, sodden, tinsel tree of a boy, weak in his jealousies and in his lusts, would help secure my kingdom.

I believed the Earl of Bothwell when he said that we were sib to each other and that I would aye be safe with him. I believed him when he said trouble waited in Edinburgh and he would keep me from harm's way in Dunbar. I gave myself over and then he took me over and that was a rough wooing indeed.

(They say he went mad, chained in a dungeon where he could neither sit nor stand. Perhaps a clumsy blade was the better bargain after all.)

No one has had a harder lesson than I, Scotland. I was born to a kingdom and now am mistress of nought but my own grave. Listen to me, learn.

Be the master of your soul Scotland. Do not blindly follow those with the guile to become powerful. Be bold, but be prepared. Never say, *they will not dare...* I believed my Cousin Elizabeth would not dare. She blustered and threatened, fierce as her father that old goat Henry, but I had royal blood in my veins (I could feel the blood running through my veins) and even when she signed the warrant for my death I was sure that counter orders followed close behind. I almost thought I heard the messenger's horse pounding to my rescue as the executioner, that sorry marksman, lowered his sword.

*A queen cannot kill a queen* the hooves sang against the cobbles. *A queen cannot kill a queen.* But the sword descended all the same.

I should have looked to my cousin's history. My Cousin Elizabeth knew how it is to wake in the night from dreams of the scaffold. Her own mother had died beneath the blade. But Elizabeth had them build a scaffold for me and then, when it was done, she had me climb it. She screamed when they told her I was dead. Screamed for fear that she had sealed her own fate (*a queen cannot kill a queen without putting*

*ideas into men's heads*) but when she had finished screaming she thought, *Better Mary's neck than mine.*

Scotland, be whole, be strong, be merciful. Let the old men girn behind their beards, age deserves respect, but it does not command obedience. Observe the company your leaders keep. If they tell you they are just, but drink with thieves, then look to your wallet. If they instruct you on morals, then look to your honour. You are the sum of your people, Scotland. The time of kings and queens is past, and no one need worry about losing their head.

Be brave in battle and kind in victory. Remember my motto, *En ma fin est mon commencement.*

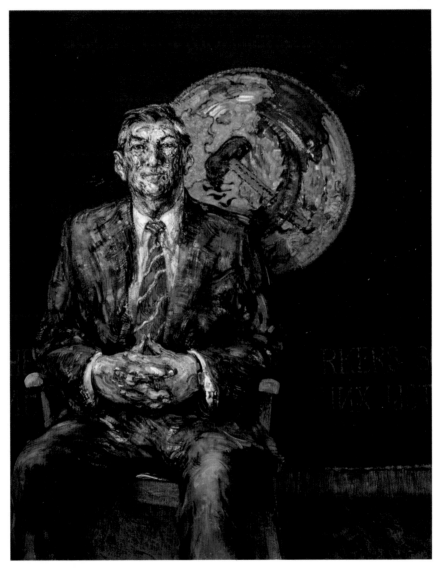

MICHAEL MCGAHEY · Maggi Hambling · Scottish National Portrait Gallery

# Jackie Kay

Here I am in ma council hoose in the classless estate o' the dead.
Pebble-dashed, gravel-pathed to where I was easily led.
Paid my dues, dork hoors doon the pit,
And when oot, chain-smoking cigarettes.
Death *is* a pit and you don't get oot o it.
And here I am wey auld enemies, Milk Snatcher
– planting crocuses! And to match her –
Heath? I pay them no heed in this democracy o the deid.
*Death shall have no dominion*, the poet said.
I can see all comrades, the living and the dead,
Compadres, been and gone, the Ashtons – Anna, Jack,
The Jimmies, Reid, Airlie, wans that watched yer back.
The Johnnie Gollans, Gordon McLennans, Alec Clarks.
And further away across dead seas and sea coal marks,
Rosa Parks, Rosa Luxemburg, Mary Seacole,
Past the jet and shining ebony, dazzling in death's ditch,
Black as pitch: Victor Jara, Che Guevara, Nelson Mandela.
And each new member of death's non-elite coalition
Takes you down the road to Perdition, Abe Moffat.
Say Hello Bob Crow. Tony Benn. Or take a walk down Memory Lane
Whatever the weather, hail or shine, there you are again,
Margaret Hunter, Eric Clark, Annie Besant, George Bolton,
Madame Allende, fu o grace, Angela Davis.
You lived your life alongside those who breathed your beliefs.
The dead have few orators. Not many articulates

In this land of disbelief. Here, down death's mine, layer on layer,
Intricate as the old coalface, the seams of the human race –
The whole strata (I'm still keeping differences in the family).
*I was a product of my class and movement. Here's a simile:*
I was as black as coal when I came up the shaft.
So it won't be me slagging my fellow spooks aff.
Talking of spooks: here's a good laugh.
Years ago, when they tapped my phone, they couldnie decipher
My accent (they wouldnie have deciphered Jimmy Wiper)
I had a blast sending the spooks to the wrong location –
Wance I sent them to a lesbian convention!
But in the main, they couldnie make oot a dickie bird,
Mair so if I'd hud whisky, my gravelly voice, grit and soot;
This is me in my new grey suit, new for this sitting.
I turned up five mornings in a row on the dot of nine.
Climbed onto the cross. Sat calm as all around was clamour.
We were the Last Room in Operations. Damn her.
You could hear the fractured sounds of dismantling Head Quarters.
Nothing to do in the efternoon but head for the SOGAT Club
And buy the painter half a pint – for a' that.
*What do you want*, she said, and I said *a wee Bells*.
*And what do you want in it*, she said, and I said *another wee Bells*.
She said I sat beautifully, by the way.
Behind my full heid of hair is the Russian banner –
See the hammer and the sickle. And now a spanner in the works!
But we miners always thought out the box
First tae introduce Jock and Tam fray Vietnam,
Tae welcome our new Chinas from China,
We'd extend a helping haund tae Mandela.
A wee country, Scotland, you and me,
Welcomed the exile, the risk-taker, the refugee.
Remember the lassie that had the floor at the AGM

Said *show sexism the door*; I shouted GOOD ON YE HEN!
Like Tam O' Shanter shouting out in the dark.
*WEEL DONE CUTTY SARK!*
*GOOD ON YE HEN!* The world is fu o' stupit men.
I got some things wrang. But I was well intentioned.
Tried to be kind. My mother wanted me to sing.
My father wanted me to fight
I fought and sang for everything that seemed right.
And if my spirit is still free, and you can hear me:
Listen to the sounds of the shale and the sea, my country.
Listen to the voices across those years,
And the old songlines of the mines,
Communities blootered, blasted, broken, so wrong.
But here is my face, fragile and strong,
and something of my spirit, I hope.
I leave you with the rest, with making the best o' this planet.
*Scotland the open – be open*
*Scotland the just – be just*
And, it goes without saying: forget me if you must.
But if you don't *my name is Mick McGahey*,
One man among many. And if you want another simile,
You could say Mick McGahey is synonymous wey…?
Loyalty maybe but don't let me get eponymous on ye.

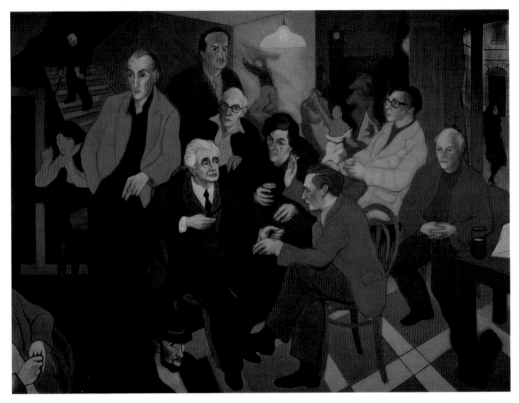

POETS' PUB · Alexander Moffat · Scottish National Portrait Gallery

# Jo Clifford

Dedicated to the memory of Stella Cartwright, 'The Muse of Rose Street' who this might be

and to

Sue Innes

who had a vision of *The Biographical Dictionary of Scottish Women* (Edinburgh University Press, 2006)

that would 'by showing the detail of so many women's lives... provide a new way of picturing Scottish life, and a rethinking of what is meant by Scottish national identity'.

Nothing dear about you Scotland.
  You vile country.
You with your cold dark days.
You with your rain that stings my face
You with your hard grey streets, your
  dirty windows
You with your niggardly closed off minds.
You with your instinct to cut everyone
  down to size
I hate you Scotland.
I hate your poets.
Look at them. So-called alpha males.
Look at them talking talking talking.
They never stop. Never.
Look at the way they toady up to that old
  man

Or say vile things about him behind his
  back
That old man with his filthy pipe and
  his tartan scarf
Praising Lenin and the power of the
  people
Declaiming all the time in that
  ridiculous made-up language of his
That's supposed to be Scots but which
  no-one can understand
And them in their pecking order all
  about him.
Look at them. Bunch of pricks.
Not that their pricks are up to much.
I know because I've had most of them
  inside me,

Waggling about or pumping up and
down
Up and down up and down in the
dreariest kind of way
And then me afterwards smiling saying
you were wonderful
It was a skill I had.
And that's why I'm painted naked with
my red stockings on
To show that I'm available.
But then see how it's also kind of
hidden that I'm naked because that,
dear Scotland,
That's just the way you feel. Just the
way you feel about sex,
Kind of furtive and ashamed, and the
way you feel about feelings too.
Why you will keep drinking just to
blank them out.
You've blanked us out too, dear
Scotland, kept us at the edge of
things
Me and Liberté and Jenny in the
courtyard
Not even bothered to paint our faces
and denied us names.
So it's the names, Scotland, it's the
names I'll tell you first:
Liberté's name is Marie Deschamps
and she fought on the barricades
And that's Jenny in the courtyard.
And I'm Stella and I belong in the stars.

Jenny's dead now. She worked the
streets to support her child
And she was a better human being than
the whole lot of you.
You with your fine words and your
frightened hearts.
You'd have used her for your furtive
pleasures only she made you pay.
But me I gave it you for nothing.
I let myself be used.
Don't judge me for that, Scotland,
because you're the same.
You've made yourself available
You've let yourself be colonised.
They've colonised your resources and
they've colonised your minds
And then you believe them, Scotland,
when they tell you you're no good
And can't be trusted to run your own
affairs.
That's why the Scotland I lived in was
so very small.
Why I'm the same, Scotland, the same
as you
Why I let myself be despoiled
Why I wrote my poems in the darkness
And never let them come to light.
But it doesn't have to be this way
Don't believe them when they tell you so
the squalor of alcohol
deceit and failure, Scotland,
the resigned and twisted bitterness

That's not for you.

The old man wasn't altogether wrong,
  Scotland,

When he said poetry should be at the
  centre of your life.

Maybe I wouldn't say poetry

Maybe I'd say creativity

Maybe I'd say love

Whatever. I won't argue.

But don't leave me at the edge,
  Scotland.

And don't deny my name.
  Acknowledge me.

I don't mind being naked. I refuse to be
  ashamed.

Right now, Scotland, when school
  children notice that I have no clothes

They get hurried on.

But your children should be fearless,
  unashamed.

Don't perpetuate abuse and shame.

Don't believe them when they tell you
  there is no other way

Don't believe them when they tell you
  they cannot help committing crimes.

They're wrong. They're very wrong.
  There is another way.

I was gifted, Scotland.

I was different, Scotland.

I laughed.

I loved my body and I loved to live.

I was clever when there was no space
  for women's cleverness

So I drank myself stupid and I felt
  ashamed.

Don't be ashamed, Scotland

Don't be ashamed to be women

Don't be ashamed to be men

Don't be ashamed to be people of both
  genders or of none

Listen to those of us who don't fit in.
  Cherish your outcasts.

Because on that day, Scotland,

That day you'll build the road to
  freedom.

That day she'll be at the centre of your
  picture

And the face she'll wear will be your
  own.

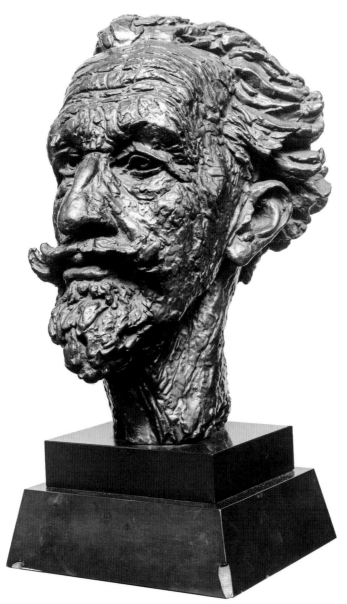

ROBERT BONTINE CUNNINGHAME GRAHAM
Sir Jacob Epstein · Scottish National Portrait Gallery

# James Robertson

Dear Scotland,

If I catch you in one of your canny, doubting, sullen moods – and, to be sure, it is a possibility – you may sniff and curl your lip at what I am about to say. Well, I have been accused before now of showing disdain for my audience, so I will rein myself in, if *you* will. Let us start with that: mutual respect.

I speak to you not as an aristocrat nor as a socialist nor as a democrat, although I am all three. God forbid that I should rank myself above anyone because of the chance circumstances of my birth and lineage. As for my political ideals, I did not inherit them but fashioned them from observation and experience. It is as a human being that I address you. And as a Scot – it is possible to be both. You may suspect me of being an impostor – too quixotic, too lean, brown and foreign-looking to be truly Scottish – but I am as true as we come: I am thrawn, romantic, disputatious and energetic, but more than these I suffer from an incurable addiction to fair play. And so, I am sure, despite your suspicions, do you.

My life has been one continuous adventure, usually on horseback, from the pampas of Argentina to the deserts of Morocco. I have been a rancher, horse-breaker, fencing master, had my head broken by a policeman in Trafalgar Square, and spent six weeks in prison for the crime of protesting against unemployment. I was a Liberal Member of Parliament but left that party to help found the Scottish Labour Party. Years later I helped found the Scottish National Party and was its first ever president. These were not the flittings of an unprincipled opportunist. Yes, I moved with the times, but my principles did not change. I have always opposed the forces

of big money and imperialism, and argued for freedom, fair wages and an eight-hour working day. My belief in Scottish independence stems not from anti-English sentiment, but from a desire to see the true potential of my country realised. I am an idealist whose ideals are rooted in reality, and it is of reality that I speak to you now.

Long ago, my ranch in Texas was attacked by Apaches. They drove off my entire stock and burnt the place to the ground. Ruinous though this was to me, my sympathies lay with the Indians. They were defending their way of life. They mistrusted and resisted progress, and with good reason, for progress, whatever humbug its lawyers and ministers preached, always meant to destroy them. *Conform or die* has ever been the byword of progress.

To justify this vicious creed we, the civilised white folks of the world, developed a special way of looking at inferior races. Apaches, Malays, Japanese, Chinese, Turks, and all the peoples of the continent of Africa – we had the arrogance to grade them according to our own scale of merit, but the one chief characteristic they shared was their difference from ourselves. To some we might grant rights, if they accepted our ideas of faith, matrimony and property – if they were rich, and washed, rode bicycles, and gambled on the Stock Exchange. If they were poor, or ventured to object to progress, then they had no rights, and everything they thought was theirs became ours.

For centuries we Scots have gone out into the world, as soldiers, traders, adventurers, or simply in search of a better life. Some of us were cruel and greedy. Some were fair-minded, and deplored wrongdoing. Now the world is coming to Scotland. So it has always done – since people first crossed the ice from Europe – but a resentful muttering has started against this latest migration: *go away, this is ours, we do not want you here.* Unchecked, the muttering may rise to shouts and threats of violence. Is this progress at work again, and should you, like the Apaches, resist it?

Dear Scotland, the cases are not the same. History has turned inside out. You need these people, and they need you. My small country, be great of mind and heart. Assert your rights, but assert your sense of justice too. Raise the flag of your humanity beside the flag of your nationhood. I promise you, they will make a bonnie pair.

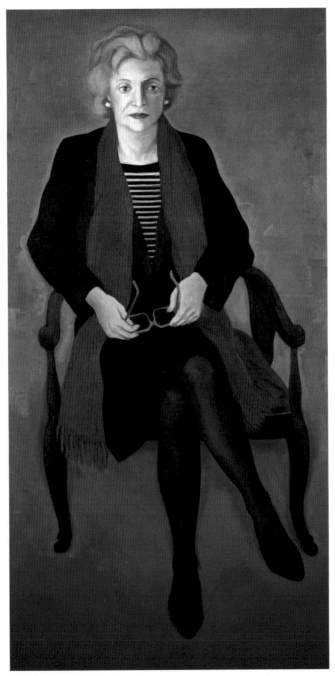

MURIEL SPARK
Alexander Moffat
Scottish National
Portrait Gallery

# Janice Galloway

Dear Scotland,

How strange that sounds. I admit I find it impossible to address a whole country without the suspicion that no one, not really, is paying any attention. Until my demise, I was telling stories to a typewriter with no idea who would give the faintest hoot about those either. But some did. It kept me going. Much tosh is spoken on the subject of *post-mortem* existence and indeed everything else besides. As the question of Scottish secession advances, in the temporal word at least, enough tosh to power a nuclear warhead seems to have come with it. Whatever else vanishes, the earth's store of tosh will never run dry. I remain heartened. Ubiquity makes nothing truthful: it makes it tediously *banal.*

First, let me mention this portrait, painted by Sandy Moffat in 1984. It is understandable that when you gaze upon it, you imagine what you gaze upon is me. It is not me. I do not mean it is a representation: I mean I do not recognise it as *myself.* It has yellow hair with a navy-blue parting, which looks dyed. My hair was never dyed. It was the same colour – light russet matching my freckles – without a trace of chemical interference to the end. Dye is a cheap public relations exercise. It is not *my style.* Lipstick, on the other hand, has no moral ambiguity. It is fun, which is very much my style. Only the red scarf – which I chose myself – seems reliable. The rest is – what it is.

I started writing seriously at the age of forty. Before that, I was gathering experience, without which I would have had nothing to say. The method I chose was to think, merely think for a few years to grasp the full dimensions of what I intended to say, then type out the whole thing as fast as possible. A fortnight is

a good target. Keep it brisk, you know? Not Mrs Tolstoy. It seemed my duty to write confidently and without timidity for if the author can't summon faith in the enterprise, who else will?

An engaging voice, plain surroundings, and the merest hint of imminent destruction I chose as essential ingredients for my stories: these things are true-to-life for everybody. *One day in the middle of the twentieth century I sat in an old graveyard which had not yet been demolished in the Kensington area of London when a young policeman stepped off the path and came over to me.* That kind of thing. The reminder of death – memento mori – is not an invitation to trepidation; it is an invitation to clarity. It is encouragement to the reader to progress joyfully rather than waste precious time. Life passes quickly either way. After death, of course, fear does not exist.

*You may think that is all very well for her. For an artist, no experience is ever wasted and wonders never cease.* That choice is not open to artists only. All it takes is a clarity. And implacable trust that wonder is worth the effort. The hard part is that leap of faith.

It is not my intention to preach. Preaching reminds me of Mr Blair, swathed in radiant white and baptising children in the River Jordan; President Clinton, loitering with his stained intern and weeping on television; Mr Darling with his pall-bearer's smile mongering doom like John Knox. If I wished to preach, I would have become a politician. I chose instead to stand alone. To think, then act confidently, without fear. What sense does the alternative make?

If you're going to do something, you may as well do it thoroughly. If you're going to be a Christian, you may as well be a Catholic. Given the opportunity to assist Scotland into fresh being, you might as well think. Think thoroughly. Dissect the full dimensions of what you intend to effect. Then act without timidity or fear – else why bother? What we give of encouragement and joy are the only things we leave behind. Some choose to be assailed by demons and trembling. For those who like that sort of thing, that is the sort of thing they

like. It is not wisdom: it is failure of imagination. Turn to the North Sea, its magnificent, uplifting light. Lift your eyes, to what lies beyond. And go on your way, rejoicing.

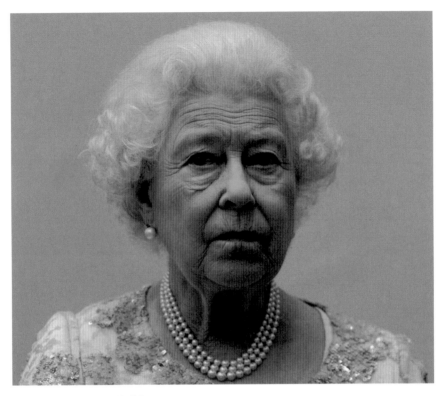

QUEEN ELIZABETH II · Carl Court

# Johnny McKnight

Dear Scotland,

Too formal.

Beloved Scotland

Too Oprah...

Dear... comrade

It'll do for now...

Dear comrade

One is apoplectic

I've devoted more than sixty years to this country and what does it get me? Civil unrest, a scalp like a sieve with all the hatpins, and the indignity, the absolute indignity of being played by Helen Fucking Mirren.

Mirren. I mean, really. I'm the face of the British monetary system, she's the face of Marks & Spencer's. This is a woman who's spent the last 30 years of her life either murdering the classics or getting her lady bumps out on film. And they put her in a fat suit you know. Sixty years of repetitive strain injury to be relegated to a fat suit.

I mean the other one, Lizzy Mark 1, she got Judi. You know where you stand with Judi – yes you get a clipped vowel and wry smile, but you still get warmth. Mirren's stately at best with all the warmth of a Ryvita and Banana buffet. And not just Judi. Oh no. I mean Lizzy cut off Mary's napper and how do we commemorate her? Cast

Blanchet. Cate's worked with Woody Allen. Mirren's worked with Linda La Plante. You can't compare.

It's undignified.

Not respectable.

But what is respect? You're not showing me it, comrade, no... friend. You're not showing me respect, friend.

Not even a chapter in that book. And I checked. Twice. Salmond hasn't called. And my voicemail is activated so...

It's the Commonwealth all over again, my friend, no, my sister...

You've forgotten what I've done for you, dear sister. Me. I drove this country forward, onwards, towards equality. I've given you the scissors to cut the tie and now not so much as a look over your shoulder to check how I'm...

When I'm in my box – you'll miss me. You will. You'll all make movies about me and they won't have Mirren. No. When I'm gone it'll be Walters. Julie'll capture it. She'll get me. She'll show it the... the...

Loss. You feel that every day. The loss. You carry it with you. Another overweight handbag, only this one can't be taken by staff.

You feel it at Balmoral. Shakes with it. Used to be a place filled with... Anne rode her first horse there, shaking at first, little tremor in the throat. 'Hold firm Anne, show them you are in charge.' Little canter, then bounded over those hills.

Mags, Mother and the ginger-let-down twirling and screaming and spilling their gin. But it was all laughter. Mags particularly. Just...

Not sister. No... dear... dear... dear...d...

D. We were at Balmoral then. It was the boys... like little crumpled boxes on our way into the church that day... you feel their loss... to lose your...

Mother.

And so young. I was lucky, we had a long time together, saw a lot of things through together. But the boys, they didn't have that... they'd been ripped, torn away from their...

...

...

You think it's going to be easy when they go. But you're never prepared for the...

The loss.

Loss of your...

I should start again.

...

Dear Mother...

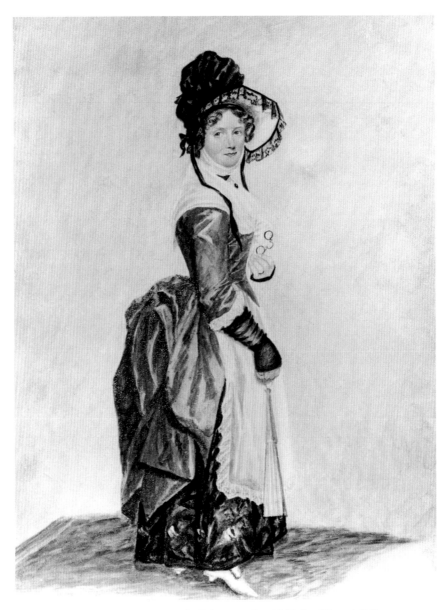

CLEMENTINA STIRLING GRAHAM · Artist Unknown · Scottish National Portrait Gallery

# Linda McLean

Here I am, on the wall beside the door
No grande dame, you'll agree; but there is more
To me than meets the eye. At a single glance
You may mark the direction of my stance,
Turned aside, leading the viewer away
As a misdirection. From what? You say;
A perfect question to the sitter. I
Am a mistress of disguise who will lie
Using furbelows and old fashioned lace
To keep you from close study of my face
Which is much younger than my dress. Eighteen
In Eighteen Hundred, playing women seen
Usually in the country; elderly
Ladies whose attire belies a deadly
Sense of the preposterous. From their lips
Framed in the Auld Scots tongue come tales and quips
Designed to startle and amaze. My friends,
Some city folks and some from Highland glens,
Delighting in my Mystifications,
Beg me ever for more. My creations
Reveal a latent skill for deception
Inherent in my line. From conception
I was destined for the double. My name
Itself – Clementina Stirling Graham
Embraces both father and mother
In its style.  The Graham from no other
Than mater's kinsman First Viscount Dundee,
No finer standard of duality:

Bloody Clavers: Presbyterian hater
And Bonnie Dundee: Jacobite saviour
At Killiecrankie. Hero. And butcher,
In the same humane being. His picture
Is hanging downstairs. His story, like mine
Becomes confection. A honeyed design
Intended to address an audience
Whose contemplation of their allegiance,
Be it to Hanover or France, has been
Clouded by misinformation. Between
One rule and another, we are reeling
In this dis-united nation. Kneeling
As we maun before a distant monarch
Whose parliamentary Tories bray and bark
At us, their educated neighbours; like slaves
To their wanton greed and neglect. Our graves
lie, testament to their true ambition –
Divide and Conquer!
      Dear Scotland, listen
While I whisper in your ear: division
Is in our human nature. Revision
Or narration will call us united
In word and action – almost hive minded
But we are nothing if not different
One from the other. A magnificent
Array of behaviours, from irreverence
To righteous God-fearing belligerence
Defines the space we occupy. The sky
Above our heads bears witness as we die
In battle for one king or his cousin,
Distracting us from business while they govern
Us according to their whim. Westminster
Cannot love our children, administer

Our common weal, or inoculation
Against the pox as it marks our nation's
Face for life. The welfare of our land
Must be first hand.
      Come closer, dear Scotland
And let me, last of all, impart this charm,
Some warning words to protect you from harm.
As well as a Whig in a wig, if you will,
That's Double-You, Aitch, Aye, Gee: Liberal
Not the hair piece – I am a Bee Keeper,
Blower of smoke on my bees, like ether,
Or sweet vitriol, to dull their senses
And neutralise their stings, their defences
Against me: honey thief, previously friend
Whom they would not hesitate to expend
If they suspected my intent. For bees
Beware the hand that feeds them, and the ease
With which the proffered hand becomes the swat
Or strikes the match reducing them to nought.
Take heed when next your vision is obscured
By finely clad ladies or gents, assured
As they bewilder with bluff and bluster,
Powered by empty bellows. Their lustre
Is a glamorous distraction, a spell
Designed for stupefaction, a death knell
To bee and being alike, while they steal
Your wax and honey; a mouth-watering seal
On your defeat. Hark then, as I depart,
A lively lass, one practised in the art
Of veiled pretence – discover your allies
Or enemies by observing the eyes,
Unwitting narrators of guile and guise
For signs that you, the viewer, are the prize.

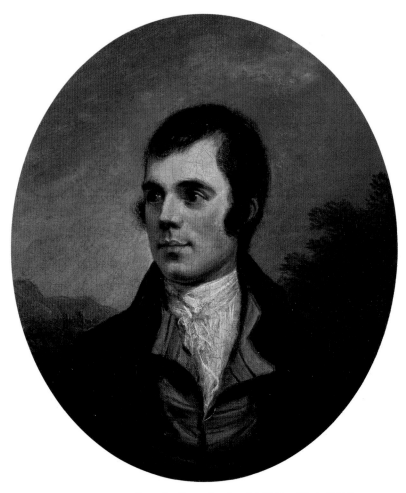

ROBERT BURNS · Alexander Nasmyth · Scottish National Portrait Gallery

# Liz Lochhead

Dear Scotland, a monologue
(*in a somewhat less-than-standard Habbie*)

[*Robert Burns, chewing on a quill-pen biro, is, scribbling, grimacing, tapping his teeth, in mid-composition…*]

*Dear Scotland! Darling Scotia!* (nah, that's shit…)
*Hear me, my Native Land!* (O.T.T? a bit)
Try *Dear Caledonia stern and wild* and hit
Th' romantic note?
'S long as you steer up young and auld, get them fit
For their big vote.

Noo, isnae this braw portait o yer Bard a gem!
A vera icon fit for stickin on a dishcloot or in a fremm.
Naysmyth prettified me in pent, noo t'all o them
I'm Rabbie,
I'm your man, the greatest, the *crème de la crème*
At Standard Habbie –

For yon is what lit-crit calls the form I wrote in
(Habitually), that dum-di-dum you all quote in
Because it *sticks*? I will allow it's *stoatin*,
This nifty stanza
I could go to sicc lengths wi, say sicc a lot in –
Largs to Lochranza,

Plockton to Peebles, Auld Ayr to Aiberdeen,
Glesca, Embra, Alloa to Wick (and all points in between)
Look to me, rhyming, to reason arguments umpteen
Wi rigour.
In't I can persuade, seduce or vent my spleen
Wi vim and vigour.

I'm quoted! *Mis*-quoted whiles, alack, tis fair
T'admit posterity's a broad-kirk kin of affair…
They pick-and-choose their bits o ye, as Scots whate'er
Their bag is

Commemmorate my birth wi whisky, neeps, hot-air
And haggis.

This Januar' hanselled in a maist auspicious year.
At Suppers cross the land, the sloganeer
And no the poet in me all sought to commandeer
As on their side.
Yup, shit-or-get-aff-the-pot-time's nearly here.
Time nor tide –

As th' poet said, nae man can tether
(An Christ that poet was me!) – But ony blether
That tries to sign me up as a better-aff-together
– Get stuffed!
I'll tell them, in language purpler than the heather,
Enough!

That 'parcel o rogues' in Seventeen-O-Seven
Eftir the Darien disaster (wha'll ne'er be forgiven)
Had us bought and sold for English gold, bastards driven
By greed and gain.
Taken us till noo (and somehow still by dissent riven)
T'get free again.

'Sh'd Scotland be an independent country?' The question
We'll shairly say Aye! to? They cannae manifest yin
Guid reason why we shouldnae. Yes! the best yin,
The only answer.
So screw yer courage, stick a Saltire in the Yessed yin
On th'voting paper.

[Robert Burns breaks down, screws up the paper he's been writing on, chucks it away, continues in prose –]

Xake! Only answer/ voting paper?... that will not do... not only does it not rhyme, barely even makes it into the assonance category... half-assed half-assonance, Rab! Plus, your prosody is pish.
Trouble is it's too obvious. Helluva hard to get going.
I mean: What kind of country doesn't want to take responsibility for it's own affairs?
Do you want Trident?
Scotland, are you a country or are you a... region?
How are you going to answer that big, that simple question?
Should Scotland be an independent country?

Vote NO and you'll be under Tory rule for ever. If middle England says so.

Vote YES and… och, dearie me, there'll likely be a bit mair to pey on taxes. If you're affluent enough to pey it, be glad and proud to be part of a democracy with the full autonomy to make compassionate and just choices – Christalmighty don't talk to me, don't talk to ma guidwife Jean, or my bairns about poverty! Awright, that's the past, what's by is by – but you on September eighteenth could make the first of many good and independent choices and wake up on the nineteenth not to 'work *as if* you were in the early days of a better nation'. But to **be alive, now,** in the early days of a better nation. And make it so.

No, I never said it would be easy.

Not in prose, rhyme, rap, hip-hop, vers libre, sonnet, syllabics, Standard Habbie, nor neer-do-well doggerel.

You'd have to make it up.

Make it up as you go along.

As I do…

Open your hearts – and hope.

Open your minds – to change.

Open up the future – because it's not yet written –

It's as Open as that it's comin yet is true!

But close the gap between what we say and what we do.

Awricht, beginigain …

[*He begins to count out the beats – to the beginning of* To A Haggis *as it happens, tho could be almost any Standard Habbie – as in* To A Mouse *or* Louse *etc.*]

Di dum, di dum dum, dum dum dum
Di dum… OK –

Let our rejection o the status quo be's robust as
Auld Scotia's wish to no see it for dust is.
And New Scotland's passion for social justice
Be oor base-note.
Look to the future! Show her what trust is:
Gie Her a Yes Vote!

## GLOSSARY

*steer up:* agitate, stir
*fremm:* Dundonian, a frame
*pent:* Dundonian, paint
*sicc:* such
*hansel:* n. a good luck gift, e.g. a coin for a new baby or one left in a purse given as a present for luck. v. to bless with a similar good-luck token
*blether:* n. one who talks nonsense

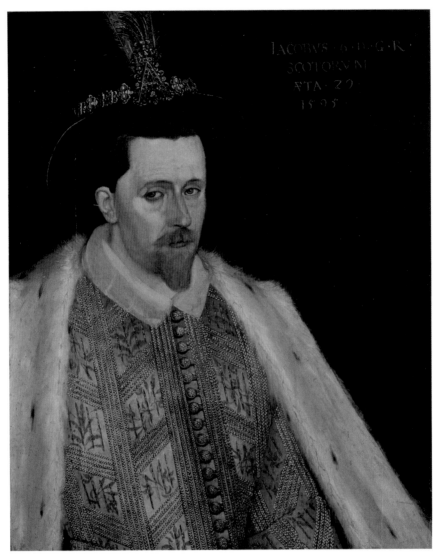

JACOBVS · 6 · D · G · R ·
SCOTORVM
ÆTA · 2 ? ·
15 95 ·

James VI + I · Adrian Vanson · Scottish National Portrait Gallery

# Iain Heggie

Wid ah be in ma richt mind bi reck'nin
That naeb'dy here assemblet is wan
    whit less than discernin?
An that yeez'll a be worth ma while
    consultin?
Oan the likelihood o ma lass nicht's
    nichtmare transpirin?

Which wis thit hauf a millenium hence
    there'll be a perturbation
A richt gefuffle up wi ma divine
    creation
Aye the bedragglet aul Scots wife'll be
    ascendin' above her station
An ponderin a divorce frae wur aul
    British nation.

Yidda thocht it wid be a o'er wi they aul
    fashiont names
Scotlant an Englant an Irelant jiss
    widny be in the frame

An a'body that's anyb'dy wid cry Unitet
    Kingdom hame
An aye be ready to mind o me as braw
    peacemakar James

Bit ah kanny har'ly credit thurrs onyhin
    in ma rotten dream
It's jiss ma troublet heid buildin up a
    heid ay steam
Well I've tae present a' ma notions tae
    baith ma soor-facet teams
An they've goat me that het up I'm shair
    I'm comin apairt at the seams

Aye – pure bilin, so I am, wi frustration
At those Westminster 'n' Edinburgh
    administrations
Well um strugglin tae unite the laws an
    economies o wur nations
An the design o ma new flag – thon's to
    be the limit o ma legislation!

Wid ye luck at this yin – is it no a joke?
It'll mibbe flatter a' ma swaggerin
    English folk
But it's like ma pair wee Scotland's
    fleein ma brutal English yoke
Kiz it's no wantin merrit tae a big fat
    pig in a poke
Get tae…
What aboot this?

[He shows the audience]

An this yin's like ma wee Scots cock
Its luck its been transformt tae a savage
    claws oot hawk
It's sittin astride ma big saft English
    flock

Threatenin tae kick fuck oot them,
    rape and run amok

But ma English think ma Scots urr
    backwart an manky
Fer tae get merrit tae ma English ye've
    tae be culchert, perfumet an swanky
They jiss want a king that likes his wee
    bit hanky panky
Tae gie them hunners o heirs at the
    drap o a silky hanky

Gey foand o'er goons an pomp thon
    greetin-facet Liz Regina
Bit no one bothert tae show her thit
    naethin kid be finer
Than to hiv a cock prise open er
    barricadet aul vagina
Or to sample a sixty-niner wi a well
    hung hunky miner

An' this wan:

[He shows the audience]

An wid ye luck at a' they unmarket
  crosses?
Dizz it no pit ye in mind o thoosans o
  Scottish losses?
An my grampa Jamesie snuffin it oan
  Flodden's boggy mosses?
Ye kidda fillt the sky – thon day – wi big
  fuck off albatrosses!

[*He bins it*]

[*He shows the audience*]

Och is thon no like a marriage that's
  become a truce
It's separate beds an neat an tidy an
  spruce
It's hauf an hauf an a carefu' absence o
  abuse
Bit fer the promotion o integration it's
  sweet fuck a use

[*Bins it*]

Mibbe I'm jiss hankerin efter ma roots
Bit that parliament doon here's faur
  o'er big fer its boots

Fer uv tae staun therr an make ma
  smart aleck case tae a' the suits
Bit no wan point I make tae thum is
  ever deemet moot

Then this effort

[*Shows them this*]

Is it no like a slaverin wrestlin match
  an ugly as sin?
Ma Scots'll say thurr o'er much rid an
  it's makin a din
But ma English'll say I've to drap the
  whale shingbang in the bin
Fer it's swimmin in blue an hiv I been
  oan the gin?

Naw I canny see thum gaun fer this
  dod o festerin tripe
But its ma lass chuck o the dice.
So wish me weel.
I'll need it wi these cunts.

[*James goes out with the Union Jack.*]

PRINCE JAMES RECEIVING HIS SON, PRINCE HENRY
Paolo Monaldi, Louis de Silvestre and Pubalacci
Scottish National Portrait Gallery

# Nicola McCartney

A Bystander in Paolo Monaldi's 'Prince James receiving his son, Prince Henry, in front of the Palazzo del Re'.

Can you see me, Scotland? If anyone can see me, you can see me. I hear that in your country your kings walk right amongst the people, that you are the fairest-minded nation on earth, so if anyone can see me, you can... What are you looking at?

They're all here, lords and ladies, priests and penitents, dealers and stealers, come to feast on the Roman ruins, rich in history. Well, their history not mine. You'll never read my history in a history book. You've come to see what they're all here to see, haven't you? The palace. Beautiful, isn't it? All that gilt and marble. Proper Roman grandeur, isn't it? My arse.

It's all fake. Every speck of it. On a normal day this is the ugliest palace in all Rome, and the gloomiest piazza. But today it's all dolled up in paint and powder like a fine lady – like a fine lady fallen on hard times, if you know what I mean... For what? For the something that's happening – over there. Something to do with your future, Scotland – oh is that what you're looking at? Your king? Or at least the one that pretends to be?

I don't care about your future. I don't. I've got more important things to think about.

I've got to think about them – in their fancy clothes and fancy wigs and fancy slaves trussed up in scarlet suits walking amongst the gentle folk as if they're free. At least they have plenty of bread in their bellies. How's that fair, eh? You tell me how that's fair? My begging bowl is empty because the fancy folk pretend not to see me. Is that why you can't see me, Scotland? Are you just like them?

I'll tell you what I see. I see my friends, the ones who can work, working, the others begging, fighting, stealing. I see my neighbour – that's her – one of those women who work the streets – with her poor child by the hand. And, yes, that's her man with his fist raised to her. That's what I see every day. Drunk. Both drunk… Good, the soldiers are beating him. Go on! Do him! Kill him! That's it! Break his bones, every last one of them, for he's broken plenty of hers… Go on!

Sorry, about that.

I'm not drunk. Well, I'm a bit drunk. You'd be if you had to sit in the shadows and take what you're thrown and sleep with whoever and scrape the scraps out of bins to stay barely alive.

And I see my son, tethered to the wall behind me. It's not good for business but I need to keep him with me or he'll wander off and kill himself, or get killed. I work when I can work. But then who takes care of him? And then them that'll have me work don't want to look at him because it scares them or makes them sad. They say he has a devil. He's just a poor soul. You shouldn't love your children too much, especially the ones God gives you as a burden. But I'm his mother. So I tie him to the wall and I sit here. With my bowl. And wait for the pennies to drop in. Or not.

You can see me, Scotland, you're just not looking, 'Because you're worried.'

And I make you sad. Because I know you want to see me, you want to help. You have the best thinkers on earth – at least that's what people say. So, I know that when you have the chance to make a new start, do it all different, make a new society, there won't be beggars like us in the new Scotland… Will there?

Of course there will. Because for there not to be, you would have to take the gamble – the gamble that in helping me, you'd end up just like me. So instead, you let them make a criminal out of me.

Don't look at me. Just see my begging bowl. Just look over there. Something's happening. It's about your future. I don't care. I have more important things to worry about.

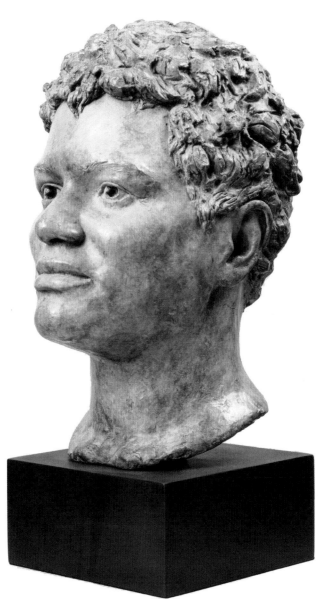

JACKIE KAY · Michael Snowden · Scottish National Portrait Gallery

# Rona Munro

Dear Scotland,

This is what I look like. This is what I looked like in the mind's eye and under the fingers of the sculptor who made this face. A pan full of moments in time, sieved through an artist's skill and simmered down to this, hot and cold metal head. This is not what I sound like, this is not my voice. This is the voice of an actress.

These are not my words, they're the words of another writer, giving me voice for these few minutes. She's worried she's being rather cheeky.

I think it's a hoot.

I thought about writing my own words for this mouth. This metal mouth. I was undecided for a while.

That might have been fun. I could have said anything and it would really have been me.

But not really here.

If you want to hear what I actually chose to say to you, Dear Scotland, that's in another room. Another tiny bit of me, floating around trying to connect to all of you.

I'm here twice today, not undecided – But definitely in two minds.

So, is this just... what I look like? Or not even that? Well... if you saw me here with breath and pulse and spit to swallow, you might not say this was the spit of me. My hair's softer than that.

I smile more than that metal mouth. I have a great smile, sweet and clear.

I'm a wee bit older than that now... though I don't look it, or maybe I do... skin is softer than bronze after all, and time never stops doing its own bit of sculpture, making each of us a new head every morning. When I'm not smiling... maybe my mouth turns down just a wee bit more than that... now... though... (maybe you can see?)... when my mouth turns down it doesn't look sad, it looks wise somehow, as I'm tasting something bitter but still managing to eat it, because I know its good for me.

And my gaze is that straight.

So, yes, that is what I look like, but you're not hearing my thoughts, and these are not my words.

My words are somewhere else, my thoughts are something else, my breathing head is not here... Which bit of me is here?

A present, a gift, freely given. I have given you my image.

I agreed to symbolic.

I agreed to be a wee bit... iconic.

There's no way round that one, if they preserve you in bronze.

That, frankly, was very brave. If a photo can catch part of your soul how much will get grabbed by this piece of metal art?

I give my self each time I send my words out to you, as honestly and skilfully as I know how, but giving you my whole head says something else, without words.

It says that poets are iconic. Planted here on a plinth I tell you that poets are part of Scotland.

I show you a brave face.
I remind you that a face like mine is part of who you are, Dear Scotland.
And whatever else you know of me, and know better, through my own words, you know I chose to allow part of my gaze to fix on you forever... or as long as metal lasts.
And, like every modern face in here, I reassure you that I cared enough to let that happen.
That this exchange was worth it, for me, even though I couldn't guide the thoughts I provoke here, the way I might with words.

You're welcome.

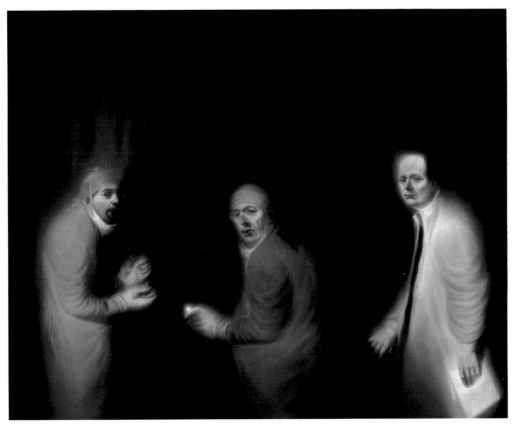

THREE ONCOLOGISTS · Ken Currie · Scottish National Portrait Gallery

# Rob Drummond

Based on a discussion with Professor RJ Steele, Professor Sir Alfred Cuschieri and Professor Sir David P Lane on 12 March 2014 at Ninewells Hospital and Medical School, Dundee.

CUSHIERI I think personally the painting frightens me and it frightens a lot of people.

LANE My mother went to see it and she went... aaaaargh!!

CUSHIERI I'm holding the end of an endoscope.

LANE And I'm holding papers. The artist, Ken Currie, made these masks of our faces. That was quite an experience.

STEELE That was really quite unpleasant.

LANE Straws up your nose.

CUSHIERI He went into it with a lot of detail and attention and preparatory work. I think it changed him as an individual as much as it changed us. More if not. It made him.

LANE I wonder sometimes if we will end up being known for being in this painting and not for our work. It's not a concern. More of an interest. A painting lives for a long time.

*Silence*

CUSHIERI You know, this is the first time we've all been together since I retired in 2003.

I came here from Malta almost fifty years ago but my grandchildren are one hundred percent Scottish. In every way. I don't believe in nationalities. I believe in human beings.

Independence would be a pity, but not a disaster. I never regretted coming here.

I believe in the Scottish genes.

LANE I was not very good at school. I squeaked into university. My dad had died from colorectal cancer when I was nineteen and that had a big effect on me. I was working in London and met someone and he said, why don't you think about coming up to Dundee.

The atmosphere in Dundee is very unique – a real passion to do something, tremendous support from the community.

STEELE I got into medicine because the qualifications I obtained after school were better than I expected and I thought I should do something with them. And I spent the first three years of medical school bitterly regretting it. It was all about rote learning and trying to be clever and make diagnoses but not really being able to do anything about it and then I did an attachment in surgery and almost from day one I knew it was what I wanted to do.

*Silence*

CUSHIERI In my view the University of Dundee has made a very big mistake.

LANE The painting represents a point in time where we were all trying to do something different.

LANE The three of us were good together because we had similar goals. But since the department closed we are proceeding in different ways. I never felt that we got the support of the medical school or the university.

STEELE We've kind of been siloed now.

LANE A lot of it was politics. Now wherever I go they are trying to set up exactly what we had.

CUSHIERI Interface between clinical science and pure research and between the physical and the biological sciences I think is the way forward. And we had that. We were the only department in the entire UK that had that.

STEELE And it was working well.

CUSHIERI But why if it was working did they...?

LANE If you are innovative you always cause trouble.

LANE You won't change the world without bringing different disciplines together. We have all this info about how to prevent cancer but we never have the people who are doing research and behavioural studies really coming together.

STEELE We had that.

LANE (*half joking*) I'm going to start crying soon.

CUSHIERI It was sad.

LANE I think we had about five good years.

*Silence*

STEELE My focus now is early detection and prevention. Reducing smoking rates is the single most important thing we can do. Looking for the wonder drug to cure advanced cancer – that's a long way down the line but at this stage it's all about lifestyle change, getting people to engage in healthy behaviour and screening.

CUSHIERI The Scottish statistics are the best in the UK.

STEELE Well. In terms of the *quality* of the data.

CUSHIERI We have good data to show...

LANE ... how awful we are.

*They all laugh for a moment. Silence.*

It's very bitter sweet.

CUSHIERI I don't do any surgery any more. I run an institute which combines biological research with physical sciences and engineering to produce the next generation of technologies. And it's now going to be moved here, to Dundee. To Ninewells.

*Pause*

I do hope that in transition it won't die.

*Silence*

I do hope that in transition it won't die.

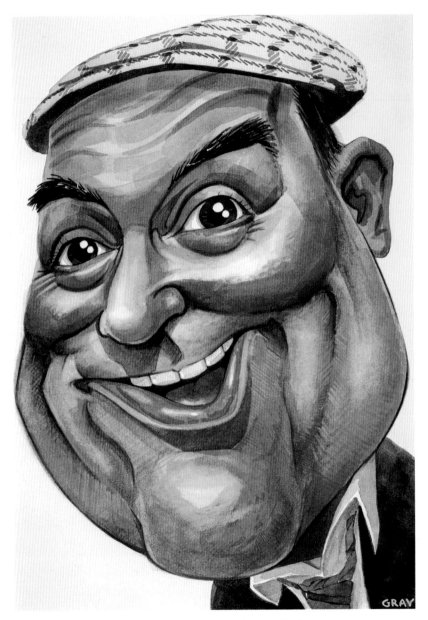

CHIC MURRAY · Derek Gray · part of the Fizzers® caricature collection

# Stuart Hepburn

[*The yodelling strains of Chic Murray singing 'China Doll' echo through the space.*

*Chic Murray emerges from the darkness wearing his ubiquitous tartan bunnet. He looks at his portrait.*

*Chic turns and takes in the audience.*]

(Pause)

... where was I? Oh aye, you see I'd got back to Bruntsfield at some Godless hour and Maidie had gone to her bed and I'd no key. So I chapped up Bob Phillips in the adjoining tenement and I explained the situation.

Bob says 'you stay the night *here* Chic... you can wake Maidie up in the morning.'

So he put me up in his spare bedroom... right next to Maidie's bedroom... four feet apart, right enough... through the stone to the tenement next door... and I got to thinking. It's a remarkable thing a tenement is it not? You can be lying there so close to your neighbour... you're only four feet apart... but it might as well be four *hundred* miles apart... remarakable... but hang on, hang on... I'm getting ahead of myself here...

You see it had all started the night before with Jimmy Tarbuck. I was in the Green Room, after his show. *Tarby & Friends*. There's a select grouping, eh? 'Tarby and friends?' Anyway the aforementioned Tarby's sitting there holding court on a sofa in the ITV Green Room... blue double breasted crushed velvet jacket, big lemon kipper tie, beige shirt, the Full Monty and he's grinning at me and he's showing off that wee gap between his teeth looking for all the world like a ferret in a wig... and who's sitting next to him but *Barry Manilow*...

... Barry Manilow who, I might say was at this point... (we're talking January 1985 here remember)... was at the very *apogee* of his world fame... so I'm tinkling on the ivories at this old Baldwin Upright that was sitting in the corner and yodelling 'China Doll' and Barry is nodding in time with it.

Now at this juncture I must point out in my own defence, drink *had* been taken.

There was a wee floor manager supplying me from a rapidly diminishing gin bottle at the side of the piano... I says to him 'Could you fit some more tonic in there son?' and he says 'Yes Mr Murray' so I said 'Well pour some more gin in then!'

Anyway, he poured me a *loud* one and I take a sip and return to the joanna when Tarby says...

'Never mind the piano Chic. Tell Barry the one about The Blackpool Wedding...' And I stop... and I turn...

Or did I turn and stop?

No no no I tell a lie I DID stop... and THEN I turned... and there I am looking at Barry Manilow. In profile.

And him with the biggest ski slope this side of the Eiger,

[*Mimics a large nose*]

And Tarbuck is sitting at the side of him with an evil glint in his eye, and I think, 'Aye aye... here's trouble.'

So Tarbuck's keeping schtum and Barry... I call him '*Barry*' but I would be a liar if I said we were close... '*Barry*' pipes up and says in this New York twang.

'The Blackpool Wedding? Is that in Scotland?'

I says 'Oh no no no it's in England, but I can't tell you *that* one...' And Barry says 'Why not... because it's English?'

I said 'No! It's because it's a story about a big nose. A very big nose.

An *extraordinarily* big nose.

Almost as big as your gigantic schnoz, Barry.'

There is a sharp intake of breath. Tarbuck tries to disappear into his velvet tux and the room goes silent. Not that the room had been making much noise up to this juncture, but

to all intents and purposes, all audible waveforms ceased. And after what seemed an age Barry starts to smile, and then laugh… and laugh… and everyone laughs … and pretty soon Tarbuck appeared with *another* bottle of gin and that got tanned in jig time and we all got a wee bit squiffy.

Ends up Barry professing undying love for Scotland, England, Blackpool, big noses and of all places Whinhill, Greenock! He invites me over to the States to appear in his show… and did I not miss the last train home to Edinburgh in all the commotion!

So that's what I'm *saying* I arrived back from London to Bruntsfield at some Godless hour, and I'm lying there in Bob Phillip's spare bedroom so close to Maidie and yet so far apart… four feet… four hundred miles… I fell asleep in the end… as you do. And I never woke up.

That was that.

It was the 29th of January, 1985. (*Pause*)

Almost 30 years…

(*He looks around him*)

And I've been thinking a lot about the space between things. Between neighbours.

Four feet of stone.

Four hundred miles of road.

… and the way I see it today… there's more pulling us together than tearing us apart… and my only hope is that we all wake up .

Because I tell you what… when you fall asleep for the last time… you're a lang time deid!

[*Chic walks off to the sound of the yodelling from 'China Doll'*]

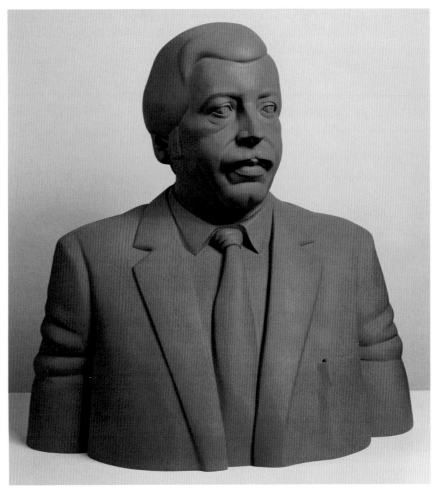

JIMMY REID · Kenny Hunter · Scottish National Portrait Gallery

# Hardeep Singh Kohli

Dear Scotland,

Orange? I know what you're thinking... Orange. For a man from Glasgow? Some kind of joke. But I'm not orange. No. I am the colour of rusted steel. Poetic, eh? I mean, folk think I should have been red, but that's too obvious. Red. Soviet Red. River red. Like the Clyde. Once...

That river ran red, Clydeside Red, with the aspirations of a generation. Second city of the Empire, a city bisected by water, Glasgow was the machine room. Someone once described the city as the lungs of the Empire. In that case the River Clyde, the wonderful Clyde was the vibrant, beating heart. But we also had spirit, we had a soul and a straightforward sense of Scottishness. The soul, the spirit of this city, was the working woman and man. As Govan grew, so did Glasgow. Then the sun set. And with the darkness the shipyards came under threat. They said they would close us down, our tools would be taken from our hands and downed. Our vibrant, beating heart was no longer profitable. We faced a bloody end from a bloody goverment hundreds of miles away. What did they expect? That we would shut up shop, let the work stop? On the contrary. Our critical faculties were not blunted, we didn't caution silence in the face of injustice. No. We didn't stage a walk out; we waged a work in. Work won and there are still shipyards on the Clyde. And what of Scotland's future today?

Oh dear, Scotland...

Where do we find ourselves? Scotland grapples with itself, friends, families, folk dividing. The nation's passionate politics poised on the verge of something; or nothing. My views were clear. I fought for an Independent Scotland. I'm not about to tell you how to vote. That was never my style. You must and you will make up your own minds. Let the orators orate and the rhetoricians rhetoricise. As we all enter the elaborate entanglement of the economics remember that there is more to a people, a culture, a nation than numbers. We saved the ship-yards without any certainty of our financial future. But I'm not here to convince you. Why would you listen to an orange man sat atop a wee kitchen table in a funny wee room in an art gallery?

Dear, dear Scotland...

We are balanced on the flimsiest fulcrum of change. Yet doubt is demonised; belief is belittled; hope is hijacked and a chasm cracks the consciousness, the core of Caledonia.

'It is our responsibility to conduct ourselves with responsibility, and with dignity, and with maturity.'

Whatever happens, however we feel about the outcome, Scotland needs to manage the maelstrom. These fault lines in our foundation cannot become fundamental to our future; they cannot permanently prescribe our politics. While we interrogate this inter-national Union we must leave room for an intra-national Union.

Scotland doesn't need a walk out; it needs a work in.

Dear Scotland,

I left school at fourteen. The library was my second home, books were amongst my dearest friends. And here I am. Jimmy Reid, cast in orange on top of a kitchen table. I'm in the Scottish Portrait Gallery, in the beautiful city of Edinburgh, home of the Enlightenment, the Athens of the North. I'm surrounded by Dukes

and Duchesses, Lairds and Ladies. Wee Jimmy Reid. From Govan through Glasgow to a Gallery. And here's the funniest thing of all. In our kitchen, growing up, we never had a table.

# Writers' biographies

## PETER ARNOTT

Peter Arnott has worked as a playwright since 1984 at the Tron, the Traverse and Royal Shakespeare Company among many others and with such collaborators as Tilda Swinton, Craig Armstrong, Michael Boyd and Simon Russell Beale. He is the winner of Theatre Management Association Awards (TMA), Creative Scotland and Fringe First Awards. He was writer in residence at the National Library of Scotland from 2008 to 2011, and at the Genomics Forum at the University of Edinburgh in 2011 to 2012.

## JO CLIFFORD

Jo Clifford is the author of about eighty plays, many of which have been performed all over the world. These include *Losing Venice, Every One* and *Faust and the Tree of Knowledge*. Her *Great Expectations* makes her the first openly transgendered woman playwright to have a play on in London's West End, her *Gospel According to Jesus Queen of Heaven* (to be revived in this year's Fringe Festival) attracted the fury of hundreds of demonstrators. She is about to work as a performer with Chris Goode. She is a proud father and grandmother.

## ROB DRUMMOND

Rob Drummond is a playwright, performer and director. He has worked with the National Theatre of Scotland, the Traverse, the Arches, the Tron, the Citizens, and the National Theatre, amongst others. Rob's wide-ranging work includes *Rob Drummond: Wrestling*, for which he trained as a professional wrestler, *Bullet Catch*, for which he trained as a magician, and *Quiz Show*, which won a Critics Award for Theatre in Scotland (CATS) for best new play in 2013. *Bullet Catch* sold out runs in London, Brighton, Belfast, New York, Michigan, Spoleto, Brazil, Sydney, New

Zealand and Hong Kong and won Total Theatre and Herald Angels Awards in 2012. Rob is currently working on a screenplay with Little Kong and Penny Dreadful Films.

## JANICE GALLOWAY

Janice is one of the UK's most versatile and gifted writers, author of novels, short stories, non-fiction, collaborative works with visual artists and typographers, opera libretti and prose-poetry. Since her first novel, *The Trick is to Keep Breathing*, her work has won international prizes, fellowships and awards. She has been writer in residence to four Scottish prisons, a Research Fellow at the British Library, and most recently, Resident Fellow for the University of Otago in New Zealand. She lives in Lanarkshire with her family and a very full library, including the entire works of Muriel Spark.

## DAVID GREIG

David is a playwright. His work for the National Theatre of Scotland includes *Dunsinane, Glasgow Girls, One Day in Spring, The Strange Undoing of Prudencia Hart, Peter Pan, The Bacchae, Futurology: A Global Review* and *Gobbo*. Other theatre work includes *The Events, Victoria, Charlie and the Chocolate Factory, The Monster in the Hall, Midsummer, Yellow Moon, Letter of Last Resort, Miniskirts of Kabul, Kyoto, Being Norwegian, Damascus, Pyrenees, San Diego, The American Pilot, Outlying Islands* and *The Cosmonaut's Last Message to the Woman He Once Loved in the Former Soviet Union*. Work with Suspect Culture includes *8000m, Lament Timeless, Mainstream* and *Airport*.

## ZINNIE HARRIS

Zinnie Harris is a playwright, director and screenwriter. Previous work with the National Theatre of Scotland includes *The Wheel*. Other plays include the multi-award winning *Further than the Furthest Thing* (National Theatre/Tron, Glasgow), *Midwinter, Solstice* (Royal Shakespeare Company), *Fall* (Traverse Theatre/Royal Shakespeare Company), *Nightingale and Chase* (Royal Court) and a version of *A Doll's House* (Donmar Warehouse). She has directed for the National Theatre of Scotland, Tron Theatre, 7:84 and the Royal Shakespeare Company. She is currently an Associate Artist at the Traverse Theatre. Her writing for television includes *Spooks, Richard is My Boyfriend* and *Born With Two Mothers*. She is currently writing a new series for BBC1.

## IAIN HEGGIE

Iain is a playwright. His work as a writer includes *Wholly Healthy Glasgow*, *American Bagpipes*, *Politics In The Park*, *The Sex Comedies*, *Wiping My Mother's Arse*, *Sauchiehall Street*, *An Experienced Woman Gives Advice*, *King of Scotland* and *Tobacco Merchant's Lawyer*. His new play *The Queen of Lucky People* (Traverse, Edinburgh/ Òran Mór, Glasgow) will be performed in April/May of this year. His awards include Edinburgh Festival Fringe First, for *Wiping My Mother's Arse* and *King of Scotland*, the John Whiting Award for *American Bagpipes* and the Mobil Playwriting Competition Special Prize for *A Wholly Healthy Glasgow*.

## STUART HEPBURN

Stuart Hepburn has been a professional actor and writer for the past thirty years. His stage play *Marco Pantani* was performed at Òran Mór last year and will be presented as part of the Edinburgh Cycling Festival in June. He was part of the team who adapted Mairi Hedderwick's *Katie Morag* for television, and is currently developing a Stirling-based long-running series for Rainmark Films and the BBC. He has written two feature films, and over seventy hours of television for programmes such as *Rebus*, *Taggart*, *McCallum*, *Hamish MacBeth* and *River City*. He is a senior lecturer in Performance and Screenwriting at the University of the West of Scotland in Ayr.

## JACKIE KAY

Jackie Kay was born and brought up in Scotland. *The Adoption Papers* (Bloodaxe) won the Forward Prize, a Saltire Prize and a Scottish Arts Council Prize. *Fiere*, her most recent collection of poems, was shortlisted for a Costa award. Her novel *Trumpet* (Picador) won the Guardian Fiction Award. *Red Dust Road* (Picador) won the Scottish Book of the Year Award and the London Book Award. She was awarded an MBE in 2006 and made a fellow of the Royal Society of Literature in 2002. She is Professor of Creative Writing at Newcastle University.

## AL KENNEDY

AL Kennedy was born in Dundee in 1965. She is the author of fifteen books: six novels, six short story collections and three works of non-fiction. She is a Fellow of

the Royal Society of Arts and a Fellow of the Royal Society of Literature and has won a number of national and international awards. She is also a dramatist for the stage, radio, TV and film and writes for a number of UK and overseas publications.

## HARDEEP SINGH KOHLI

Hardeep is a writer and broadcaster. He is a regular on BBC 1's *Question Time* and *This Week* with Andrew Neil, and was a former *Newsnight Review* presenter and contributor. For Channel 4, he has written and presented the BAFTA award-winning *In Search of the Tartan Turban, Hardeep Does...* and the three part gambling series *£50 says you'll watch this*, and presented *The Beginners Guide To L R Ron Hubbard*.

## LIZ LOCHHEAD

Liz Lochhead is a Glasgow-based poet and playwright. In 2011 she became the Makar or National Poet of Scotland, and has been, for over 40 years, in demand all over the UK and abroad for performances of her work. Soon after graduating from Glasgow School of Art in 1970, her first, and best-selling, collection of poems, *Memo for Spring* (1972) was published. This was followed by *Dreaming Frankenstein, True Confessions, The Colour of Black & White* and *A Choosing* and her recent *Selected Poems*. Her original plays include: *Blood and Ice* (1982), *Mary Queen of Scots Got Her Head Chopped Off* (1987), *Perfect Days* (1998) and *Good Things* (2004). Her translations and adaptations include the three great rhyming Molière comedies, *Tartuffe* (1986) *Miseryguts (the Misanthrope:* 2002) and *Educating Agnes (School for Wives:* 2008) and award-winning versions of the Greek Tragedies *Medea* and *Thebans*.

## IAIN FINLAY MACLEOD

Iain Finlay comes from the Isle of Lewis and is a native Gaelic speaker. As well as theatre, he writes fiction, film and radio. Previous writing for theatre includes *Somersaults* (National Theatre of Scotland), *The Pearlfisher, I Was a Beautiful Day, Homers, Alexander Salamander* (Traverse Theatre) and *St Kilda – The Opera* (Pròiseact nan Ealan). His plays have been performed in many countries – the UK, France, Germany, Belgium, Austria and the US. Iain is currently Associate Artist (Gaelic) at the National Theatre of Scotland.

## NICOLA MCCARTNEY

Nicola is a playwright, director and dramaturge. Originally from Belfast, she trained as a director at Charabanc Theatre Company, Belfast, Citizens, Glasgow and G&J Productions. She was Artistic Director of new writing theatre company, lookOUT from 1992 to 2002. As a playwright her work includes *A Sheep Called Skye* (National Theatre of Scotland), *Laundry, Easy, Home, Cave Dwellers* (7:84), *Heritage* (Traverse), *Convictions, 1 IN 5* (Tinderbox), *Underworld* (Frantic Assembly), *Lifeboat* (Catherine Wheels), *Rough Island* (Mull Theatre/ Òran Mór). Nicola was one of the inaugural Associate Playwrights of the Playwrights' Studio Scotland. She has been Writer in Residence at the University of Ulster and at Shetland Arts amongst others, and is currently Lecturer in Writing for Performance at the University of Edinburgh.

## JOHNNY MCKNIGHT

Johnny trained at Royal Scottish Academy for Music and Drama (RSAMD) and works as a writer, director, performer and educator. His writing work includes *Wendy Hoose* (Birds of Paradise/Random Accomplice), *The Incredible Adventures of See Thru Sam* (Random Accomplice), *Little Johnny's Big Gay Wedding* (National Theatre of Scotland/Random Accomplice), *Curse of Maccabre Opera House* and *Last One Out* (Scottish Opera), as well as nine contemporary pantomimes to date for the Royal Lyceum, Tron Theatre and macrobert. Johnny is currently under commission to write *News Just In* (Random Accomplice), *Aladdin* (macrobert) and *Miracle on 34 Parnie Street* (Tron Theatre).

## LINDA MCLEAN

Linda comes from Glasgow. She has written many plays; some of them have won awards. She is currently working in the USA, where *Sex and God* and *Any Given Day* are opening and the world premiere of *Every Five Minutes* at the Magic Theatre in San Francisco will be playing throughout April. She is collaborating with three other women on a play called *Love and Fascism* for the Istanbul International Theatre Festival in May. She was the Traverse Theatre's creative fellow at the Institute for Advanced Studies in Humanities (IASH) in 2010/11. She is also chair of the Playwrights' Studio Scotland.

## RONA MUNRO

Rona's writing credits for the National Theatre of Scotland include an adaptation of *The House of Bernarda Alba* and *The James Plays* (with Edinburgh International Festival and National Theatre of Great Britain) to be performed from August 2014. Other recent theatre writing credits include *Donny's Brain* (Hampstead Downstairs), *The Astronaut's Chair* (Drum, Plymouth), *Pandas* (Traverse, Edinburgh), *Little Eagles* (Royal Shakespeare Company), *The Last Witch* (Edinburgh International Festival) and *Iron* (Traverse, Edinburgh – winner of the John Whiting award). Television work includes the BAFTA nominated *Bumping the Odds* and *Rehab*. Film work includes *Ladybird Ladybird* and *Oranges and Sunshine*. Radio work includes *The Stanley Baxter Playhouse*. She is the writing half of Scotland's award winning women's theatre company The MsFits.

## JAMES ROBERTSON

James Robertson is a writer of fiction, a poet, editor and essayist. His novels include *Joseph Knight* (which won both the Saltire and Scottish Arts Council Book of the Year awards in 2003/04), *The Testament of Gideon Mack* (longlisted for the Man Booker Prize), *And the Land Lay Still* (winner of the Saltire Book of the Year award) and *The Professor of Truth*. He co-founded and is general editor of the Itchy Coo imprint, which publishes books in Scots for young readers. His latest project, *365*, in which he posts a daily 365-word story online every day of 2014, can be accessed at fivedials.com.

## ALI SMITH

Ali Smith was born in Inverness in 1962 and lives in Cambridge. Her books have won, and been shortlisted, for many awards. Her latest books are *There But For The* (2011), winner of the Hawthornden Prize, *Artful* (2012), winner of the Foyles/Bristol Festival of Ideas Best Book 2013, and, forthcoming, the novel *How To Be Both* (2014).

## LOUISE WELSH

Louise Welsh is the author of six novels, most recently *The Girl on the Stairs* and *A Lovely Way to Burn*. She has written many short stories, articles, reviews and radio features and has written for the stage, including libretti for opera. Louise has won several fellowships and awards, including a South Bank Sky Arts award for *Ghost Patrol* (Scottish Opera/Music Theatre Wales) in 2013. She was a fellow on the University of Iowa's International Writing Programme in 2011 and Writer in Residence at the University of Glasgow and Glasgow School of Art (2010 to 2012).

# Directors' biographies

## JOE DOUGLAS

Co-Director

Joe Douglas trained in directing at Rose Bruford College and was Trainee Director for the National Theatre of Scotland in 2007–8. Previous directing credits for the National Theatre of Scotland include *The Last Polar Bears*, *Our Teacher's A Troll*, *Allotment* and re-directing the 2013 world tour of *Black Watch*. Recent directing credits include *Bloody Trams: A Rapid Response* (Traverse), *The BFG* (Dundee Rep), *The Reprobates* (HighTide), *The Drowning Pond*, *Jabberwocky* (Youth Music Theatre), *Thank You, Videotape* and *The Sunday Lesson* (Òran Mór, Glasgow). His autobiographical play, *Educating Ronnie* (Macrobert/Utter), toured Scotland and won a Fringe First in 2012. He is Co-Artistic Director of Utter.

## CATRIN EVANS

Co-Director

Catrin is a director and playwright based in Glasgow. Her most recent production, *Leaving Planet Earth*, which she co-wrote and co-directed with Lewis Hetherington, was produced by Grid Iron as part of Edinburgh International Festival 2013. Other recent directing credits include *Some Other Mother* (Tron, Glasgow), *Sweet Silver Song of the Lark* (A Play, A Pie and A Pint, Òran Mór, Glasgow), *Fragile* (Theatre Uncut) and *Could You Please Look into the Camera* (A Play, A Pie and A Pint, Òran Mór, Glasgow/ National Theatre of Scotland). Catrin is also the Artistic Director of A Moment's Peace Theatre Company. She is currently creating their latest show, *Endurance*, with women from all across Glasgow. The production is being co-produced with the Arches as part of the Commonwealth Festival 2014.

## **Luath** Press Limited
*committed to publishing well written books worth reading*

LUATH PRESS takes its name from Robert Burns, whose little collie Luath (*Gael.,* swift or nimble) tripped up Jean Armour at a wedding and gave him the chance to speak to the woman who was to be his wife and the abiding love of his life. Burns called one of 'The Twa Dogs' Luath after Cuchullin's hunting dog in Ossian's *Fingal*. Luath Press was established in 1981 in the heart of Burns country, and now resides a few steps up the road from Burns' first lodgings on Edinburgh's Royal Mile.

Luath offers you distinctive writing with a hint of unexpected pleasures.

Most bookshops in the UK, the US, Canada, Australia, New Zealand and parts of Europe either carry our books in stock or can order them for you. To order direct from us, please send a £sterling cheque, postal order, international money order or your credit card details (number, address of cardholder and expiry date) to us at the address below. Please add post and packing as follows: UK – £1.00 per delivery address; overseas surface mail – £2.50 per delivery address; overseas airmail – £3.50 for the first book to each delivery address, plus £1.00 for each additional book by airmail to the same address. If your order is a gift, we will happily enclose your card or message at no extra charge.

**Luath** Press Limited
543/2 Castlehill
The Royal Mile
Edinburgh EH1 2ND
Scotland
Telephone: 0131 225 4326 (24 hours)
Fax: 0131 225 4324
email: sales@luath.co.uk
Website: www.luath.co.uk

ILLUSTRATION: IAN KELLAS